Mary Eng

Hold on TIGHT

2011 calendar

**Andrews McMeel
Publishing, LLC**
Kansas City • Sydney • London

Hold on Tight 2011 Calendar

© 2010 Mary Engelbreit Ink. Printed in China.

For information write Andrews McMeel Publishing, LLC
an Andrews McMeel Universal company
1130 Walnut Street, Kansas City, Missouri 64106.

ISBN-13: 978-0-7407-9013-3

www.andrewsmcmeel.com
www.maryengelbreit.com

Start dates for the seasons of the year are presented in U.S. Eastern Standard Time.

2011

January
s	m	t	w	t	f	s
						1
2	3	4	5	6	7	8
9	10	11	12	13	14	15
16	17	18	19	20	21	22
23	24	25	26	27	28	29
30	31					

February
s	m	t	w	t	f	s
		1	2	3	4	5
6	7	8	9	10	11	12
13	14	15	16	17	18	19
20	21	22	23	24	25	26
27	28					

March
s	m	t	w	t	f	s
		1	2	3	4	5
6	7	8	9	10	11	12
13	14	15	16	17	18	19
20	21	22	23	24	25	26
27	28	29	30	31		

April
s	m	t	w	t	f	s
					1	2
3	4	5	6	7	8	9
10	11	12	13	14	15	16
17	18	19	20	21	22	23
24	25	26	27	28	29	30

May
s	m	t	w	t	f	s
1	2	3	4	5	6	7
8	9	10	11	12	13	14
15	16	17	18	19	20	21
22	23	24	25	26	27	28
29	30	31				

June
s	m	t	w	t	f	s
			1	2	3	4
5	6	7	8	9	10	11
12	13	14	15	16	17	18
19	20	21	22	23	24	25
26	27	28	29	30		

July
s	m	t	w	t	f	s
					1	2
3	4	5	6	7	8	9
10	11	12	13	14	15	16
17	18	19	20	21	22	23
24	25	26	27	28	29	30
31						

August
s	m	t	w	t	f	s
	1	2	3	4	5	6
7	8	9	10	11	12	13
14	15	16	17	18	19	20
21	22	23	24	25	26	27
28	29	30	31			

September
s	m	t	w	t	f	s
				1	2	3
4	5	6	7	8	9	10
11	12	13	14	15	16	17
18	19	20	21	22	23	24
25	26	27	28	29	30	

October
s	m	t	w	t	f	s
						1
2	3	4	5	6	7	8
9	10	11	12	13	14	15
16	17	18	19	20	21	22
23	24	25	26	27	28	29
30	31					

November
s	m	t	w	t	f	s
		1	2	3	4	5
6	7	8	9	10	11	12
13	14	15	16	17	18	19
20	21	22	23	24	25	26
27	28	29	30			

December
s	m	t	w	t	f	s
				1	2	3
4	5	6	7	8	9	10
11	12	13	14	15	16	17
18	19	20	21	22	23	24
25	26	27	28	29	30	31

January

sunday	monday	tuesday	wednesday	thursday	friday	saturday
						1 New Year's Day Kwanzaa ends (USA)
2	3 New Year's Day (observed) (Ireland, NZ, UK, Australia—except NSW)	4 Bank Holiday (Scotland)	5	6	7	8
9	10	11	12	13	14	15
16	17 Martin Luther King Jr.'s Birthday (observed) (USA)	18	19	20	21	22
23	24	25	26 Australia Day	27	28	29
30	31					

February

sunday	monday	tuesday	wednesday	thursday	friday	saturday
		1	2	3	4	5
6 Waitangi Day (NZ)	7	8	9	10	11	12
13	14 St. Valentine's Day	15	16	17	18	19
20	21 Presidents' Day (USA)	22	23	24	25	26
27	28					

March

sunday	monday	tuesday	wednesday	thursday	friday	saturday
		1 St. David's Day (UK)	2	3	4	5
6	7 Labour Day (Australia—WA)	8 International Women's Day	9 Ash Wednesday	10	11	12
13 Daylight Saving Time begins (USA)	14 Eight Hours Day (Australia—TAS) Labour Day (Australia—VIC) Canberra Day (Australia—ACT) Commonwealth Day (Australia, Canada, NZ, UK)	15	16	17 St. Patrick's Day	18	19
20 Purim First day of spring	21	22	23	24	25	26
27	28	29	30	31		

All Jewish holidays begin at sundown the previous day.

April

sunday	monday	tuesday	wednesday	thursday	friday	saturday
					1 April Fools' Day	2
3 Mothering Sunday (Ireland, UK)	4	5	6	7	8	9
10	11	12	13	14	15	16
17 Palm Sunday	18	19 Passover	20	21	22 Good Friday (Western) Holy Friday (Orthodox) Earth Day	23 Easter Saturday (Australia—except TAS, WA) St. George's Day (UK)
24 Easter (Western, Orthodox)	25 Easter Monday (Australia, Canada, Ireland, NZ, UK—except Scotland) Anzac Day (NZ, Australia— except SA, VIC)	26 Passover ends Anzac Day (observed) (Australia—SA, VIC, WA)	27 Administrative Professionals Day (USA)	28	29 Arbor Day (USA)	30

All Jewish holidays begin at sundown the previous day.

May

sunday	monday	tuesday	wednesday	thursday	friday	saturday
1 May Day	2 Labour Day (Australia—QLD) May Day (observed) (Australia—NT) Early May Bank Holiday (Ireland, UK)	3 National Teacher Day (USA)	4	5	6 Nurses Day (USA)	7
8 Mother's Day (USA, Australia, Canada, NZ)	9	10	11	12	13	14
15	16	17	18	19	20	21 Armed Forces Day (USA)
22	23 Victoria Day (Canada)	24	25	26	27	28
29	30 Memorial Day (USA) Spring Bank Holiday (UK)	31				

June

sunday	monday	tuesday	wednesday	thursday	friday	saturday
			1	2	3	4
5	6 Queen's Birthday (NZ) Foundation Day (Australia—WA) Bank Holiday (Ireland)	7	8	9	10	11
12	13 Queen's Birthday (Australia—except WA)	14 Flag Day (USA)	15	16	17	18
19 Father's Day (USA, Canada, Ireland, UK)	20	21 First day of summer	22	23	24	25
26	27	28	29	30		

July

					1	2
					Canada Day	
3	4	5	6	7	8	9
	Independence Day (USA)					
10	11	12	13	14	15	16
17	18	19	20	21	22	23
24	25	26	27	28	29	30
31						

August

sunday	monday	tuesday	wednesday	thursday	friday	saturday
	1 Ramadan Bank Holiday (Ireland, UK—Scotland, Australia—NSW) Picnic Day (Australia—NT)	2	3	4	5	6
7	8	9	10	11	12	13
14	15	16	17	18	19	20
21	22	23	24	25	26	27
28	29 Summer Bank Holiday (UK—except Scotland)	30 Eid al-Fitr	31			

All Islamic holidays begin at sundown the previous day.

September

sunday	monday	tuesday	wednesday	thursday	friday	saturday
				1	2	3
4 Father's Day (Australia, NZ)	5 Labor Day (USA, Canada)	6	7	8	9	10
11 National Grandparents Day (USA)	12	13	14	15	16	17
18	19	20	21 U.N. International Day of Peace	22	23 First day of autumn	24
25	26	27	28	29 Rosh Hashanah	30 Rosh Hashanah ends	

All Jewish holidays begin at sundown the previous day.

October

sunday	monday	tuesday	wednesday	thursday	friday	saturday
						1
2	3 Labour Day (Australia—ACT, NSW, SA) Queen's Birthday (Australia—WA)	4	5	6	7	8 Yom Kippur
9	10 Columbus Day (USA) Thanksgiving (Canada)	11	12	13	14	15
16 National Boss Day (USA)	17	18	19	20	21	22
23	24 United Nations Day Labour Day (NZ)	25	26	27	28	29
30	31 Halloween Bank Holiday (Ireland)					

All Jewish holidays begin at sundown the previous day.

November

sunday	monday	tuesday	wednesday	thursday	friday	saturday
		1	2	3	4	5
6 Eid al-Adha Daylight Saving Time ends (USA)	7	8 Election Day (USA)	9	10	11 Veterans' Day (USA) Remembrance Day (Canada, Ireland, UK)	12
13	14	15	16	17	18	19
20	21	22	23	24 Thanksgiving (USA)	25	26
27	28	29	30 St. Andrew's Day (UK)			

All Islamic holidays begin at sundown the previous day.

December

sunday	monday	tuesday	wednesday	thursday	friday	saturday
				1	2	3
4	5	6	7	8	9	10 Human Rights Day
11	12	13	14	15	16	17
18	19	20	21 Hanukkah	22 First day of winter	23	24 Christmas Eve
25 Christmas Day	26 Kwanzaa begins (USA) Christmas Day (observed) (UK, Australia—except TAS, VIC) Boxing Day (Canada, NZ, Australia—TAS, VIC) St. Stephen's Day (Ireland)	27 Christmas Day (observed) (Ireland, NZ, Australia—TAS, VIC) Boxing Day (observed) (UK, Australia—except SA, TAS, VIC) Proclamation Day (Australia—SA)	28 Hanukkah ends	29	30	31

All Jewish holidays begin at sundown the previous day.

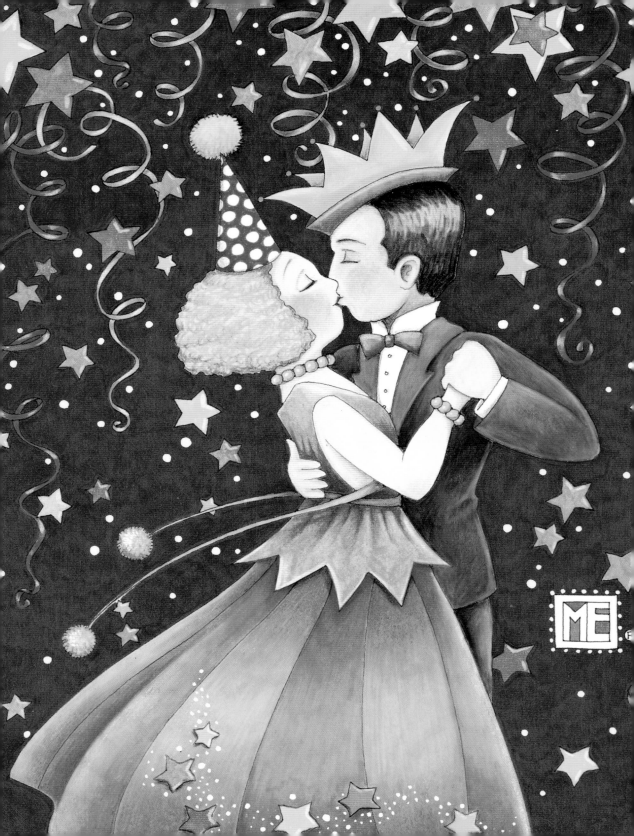

Dec 27 - Jan 2

> *If* I held you any closer
> I would be on the other
> side of you.
> —Groucho Marx

27
monday

Christmas Day (observed) (NZ, UK, Australia—ACT, NT, SA, TAS, WA)
Boxing Day (observed) (Australia—NSW, QLD, VIC)

30
thursday

28
tuesday

Boxing Day (observed) (NZ, UK, Australia—ACT, NT, TAS, WA)
Proclamation Day (Australia—SA)

31
friday

29
wednesday

1
saturday

New Year's Day
Kwanzaa ends (USA)

2
sunday

December '10

s	m	t	w	t	f	s
			1	2	3	4
5	6	7	8	9	10	11
12	13	14	15	16	17	18
19	20	21	22	23	24	25
26	27	28	29	30	31	

January

s	m	t	w	t	f	s
						1
2	3	4	5	6	7	8
9	10	11	12	13	14	15
16	17	18	19	20	21	22
23	24	25	26	27	28	29
30	31					

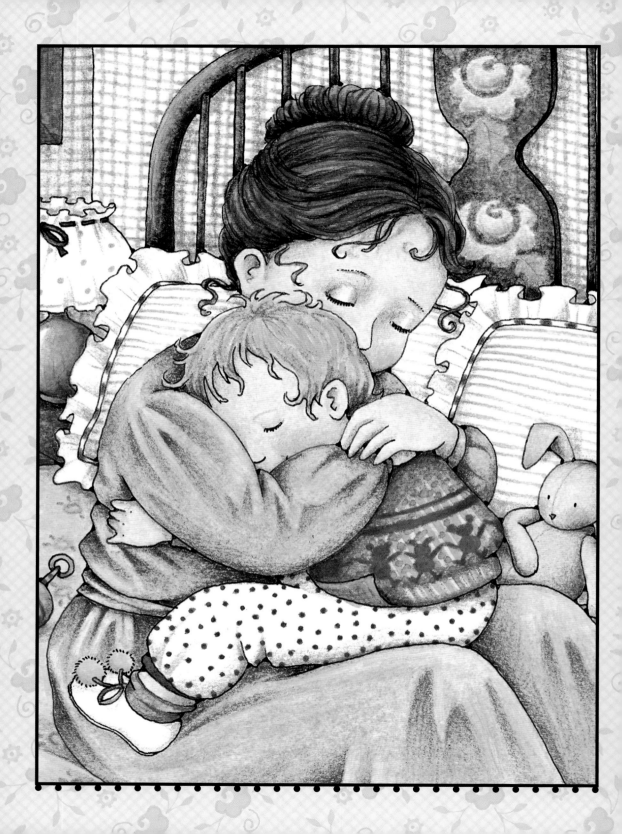

*H*ugs are the universal medicine.
—Unknown

Jan 3 - 9

New Year's Day (observed) (Ireland, NZ, UK,
Australia—except NSW)

3
monday

6
thursday

Bank Holiday (Scotland)

4
tuesday

7
friday

5
wednesday

8
saturday

9
sunday

\	January					
s	m	t	w	t	f	s
						1
2	3	4	5	6	7	8
9	10	11	12	13	14	15
16	17	18	19	20	21	22
23	24	25	26	27	28	29
30	31					

\	February					
s	m	t	w	t	f	s
		1	2	3	4	5
6	7	8	9	10	11	12
13	14	15	16	17	18	19
20	21	22	23	24	25	26
27	28					

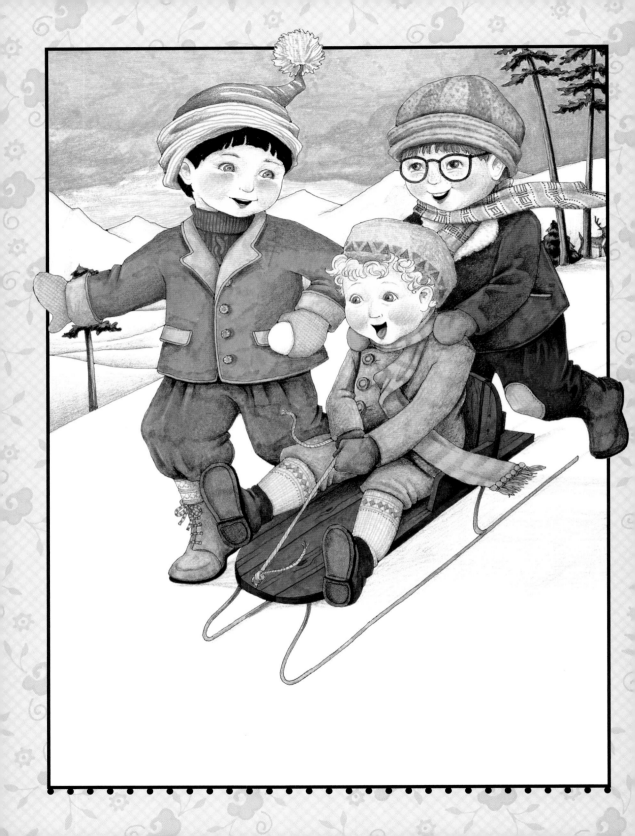

Jan 10 - 16

10 monday

13 thursday

11 tuesday

14 friday

12 wednesday

15 saturday

16 sunday

January						
s	m	t	w	t	f	s
						1
2	3	4	5	6	7	8
9	10	11	12	13	14	15
16	17	18	19	20	21	22
23	24	25	26	27	28	29
30	31					

February						
s	m	t	w	t	f	s
		1	2	3	4	5
6	7	8	9	10	11	12
13	14	15	16	17	18	19
20	21	22	23	24	25	26
27	28					

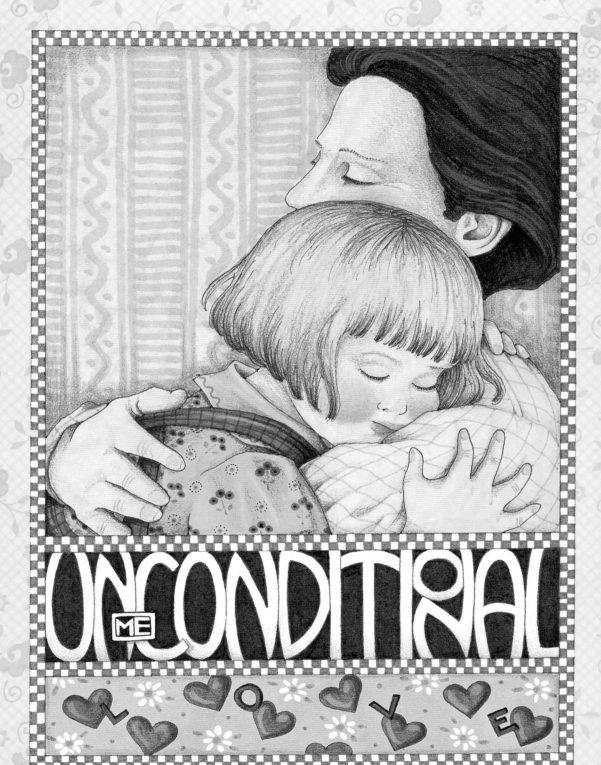

The only love worthy of a name
is unconditional.
—John Powell

Jan 17 - 23

Martin Luther King Jr.'s Birthday (observed) (USA)

17
monday

20
thursday

18
tuesday

21
friday

19
wednesday

22
saturday

23
sunday

January

s	m	t	w	t	f	s
						1
2	3	4	5	6	7	8
9	10	11	12	13	14	15
16	17	18	19	20	21	22
23	24	25	26	27	28	29
30	31					

February

s	m	t	w	t	f	s
		1	2	3	4	5
6	7	8	9	10	11	12
13	14	15	16	17	18	19
20	21	22	23	24	25	26
27	28					

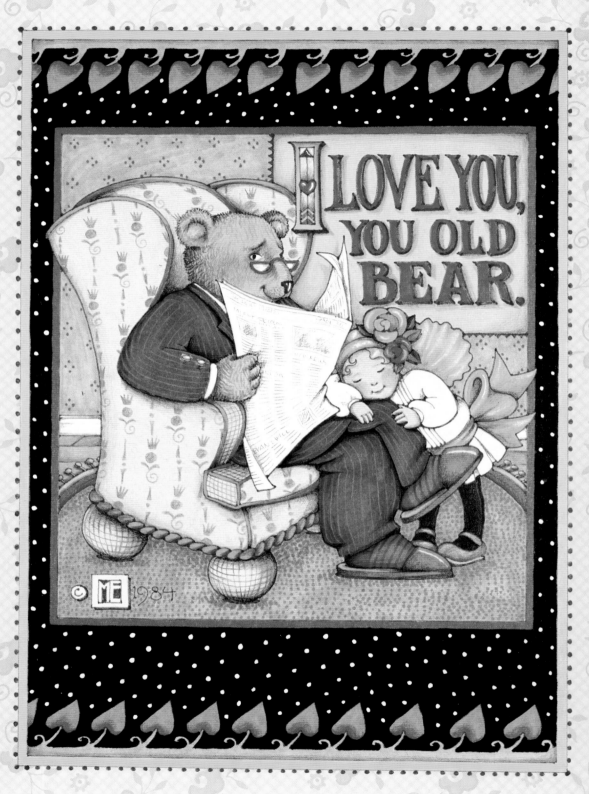

*S*ometimes it's better
to put love into hugs
than to put it into words.

—Unknown

Jan 24 - 30

24
monday

27
thursday

25
tuesday

28
friday

Australia Day

26
wednesday

29
saturday

30
sunday

January						
s	m	t	w	t	f	s
						1
2	3	4	5	6	7	8
9	10	11	12	13	14	15
16	17	18	19	20	21	22
23	24	25	26	27	28	29
30	31					

February						
s	m	t	w	t	f	s
		1	2	3	4	5
6	7	8	9	10	11	12
13	14	15	16	17	18	19
20	21	22	23	24	25	26
27	28					

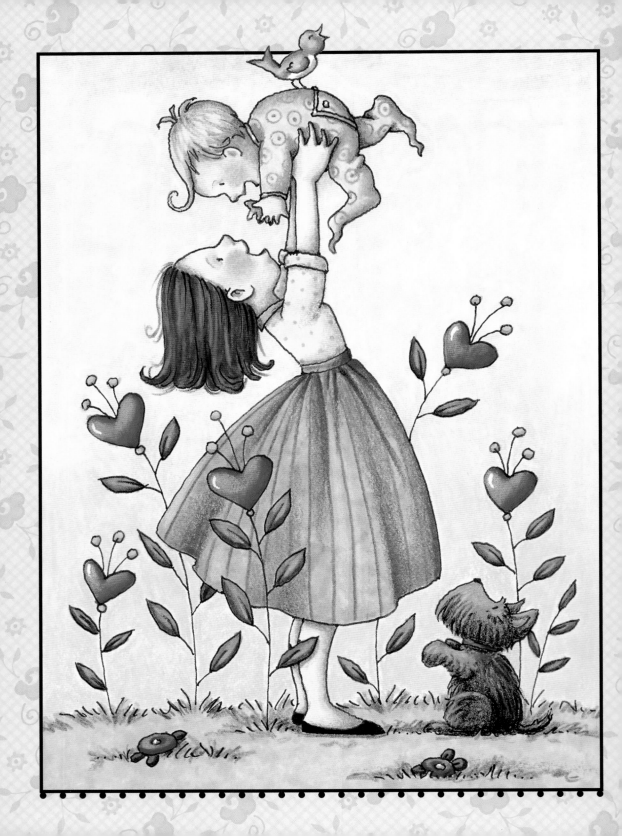

*C*hildren are a handful sometimes, a heart full all the time.
—Unknown

Jan 3I - Feb 6

3I
monday

3
thursday

I
tuesday

4
friday

2
wednesday

5
saturday

Waitangi Day (NZ)

6
sunday

January
s m t w t f s
1
2 3 4 5 6 7 8
9 10 11 12 13 14 15
16 17 18 19 20 21 22
23 24 25 26 27 28 29
30 31

February
s m t w t f s
1 2 3 4 5
6 7 8 9 10 11 12
13 14 15 16 17 18 19
20 21 22 23 24 25 26
27 28

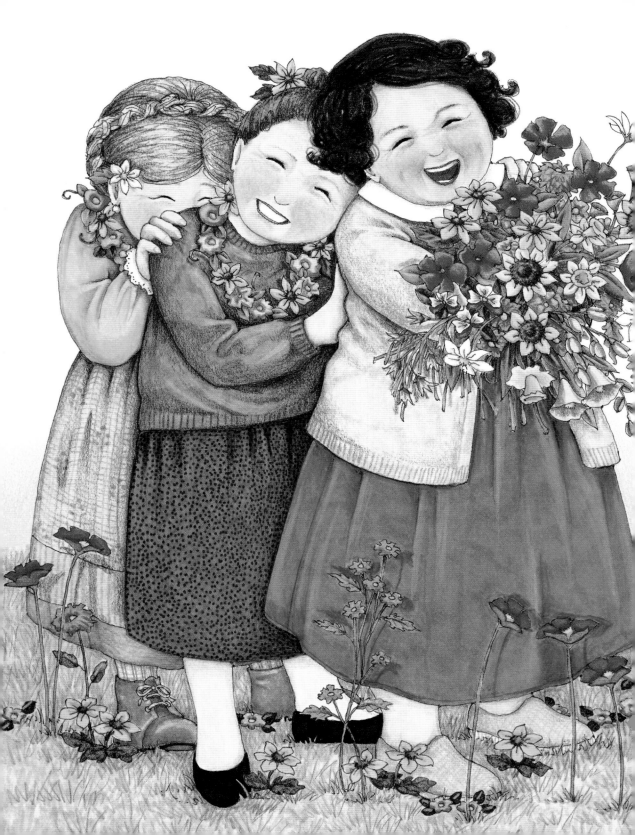

*U*nderstand that friends come and go, but with a precious few you should hold on. The older you get, the more you need the people who knew you when you were young.

—Mary Schmich

Feb 7 - 13

7 monday

8 tuesday

9 wednesday

10 thursday

11 friday

12 saturday

13 sunday

February						
s	m	t	w	t	f	s
		1	2	3	4	5
6	7	8	9	10	11	12
13	14	15	16	17	18	19
20	21	22	23	24	25	26
27	28					

March						
s	m	t	w	t	f	s
		1	2	3	4	5
6	7	8	9	10	11	12
13	14	15	16	17	18	19
20	21	22	23	24	25	26
27	28	29	30	31		

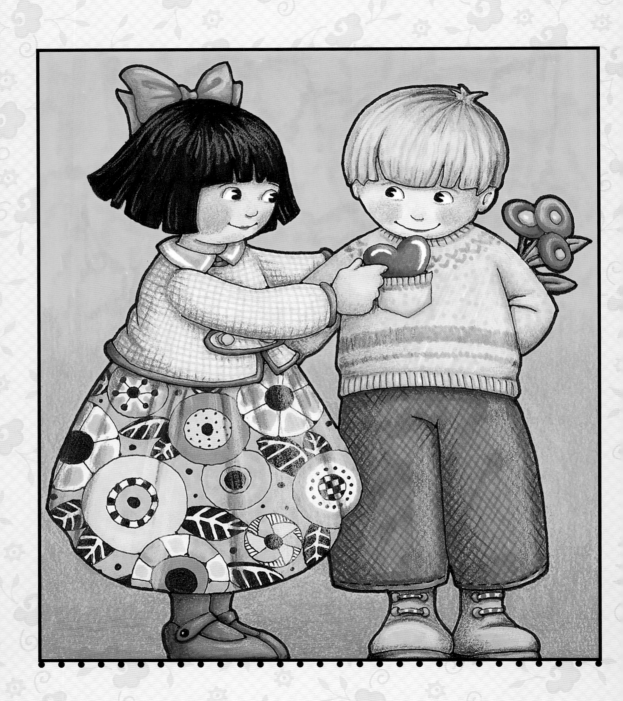

Nobody has ever measured, not even poets, how much the heart can hold.

—Zelda Fitzgerald

Feb 14 - 20

St. Valentine's Day

14
monday

17
thursday

15
tuesday

18
friday

16
wednesday

19
saturday

20
sunday

February						
s	m	t	w	t	f	s
		1	2	3	4	5
6	7	8	9	10	11	12
13	14	15	16	17	18	19
20	21	22	23	24	25	26
27	28					

March						
s	m	t	w	t	f	s
		1	2	3	4	5
6	7	8	9	10	11	12
13	14	15	16	17	18	19
20	21	22	23	24	25	26
27	28	29	30	31		

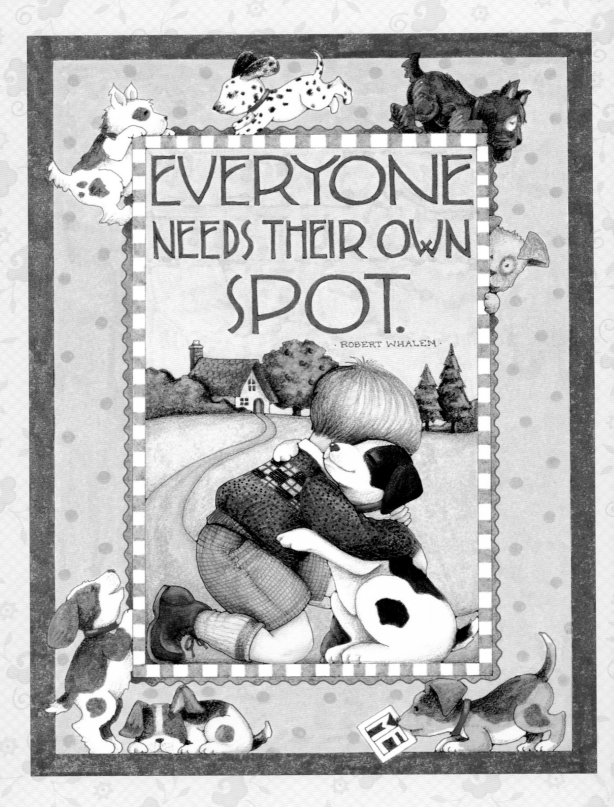

EVERYONE NEEDS THEIR OWN SPOT.

· ROBERT WHALEN ·

*O*ur task must be to free ourselves...
by widening our circle of compassion
to embrace all living creatures
and the whole of nature and its beauty.
—Albert Einstein

Feb 21 - 27

Presidents' Day (USA)

21 monday

24 thursday

22 tuesday

25 friday

23 wednesday

26 saturday

27 sunday

February

s	m	t	w	t	f	s
		1	2	3	4	5
6	7	8	9	10	11	12
13	14	15	16	17	18	19
20	21	22	23	24	25	26
27	28					

March

s	m	t	w	t	f	s
		1	2	3	4	5
6	7	8	9	10	11	12
13	14	15	16	17	18	19
20	21	22	23	24	25	26
27	28	29	30	31		

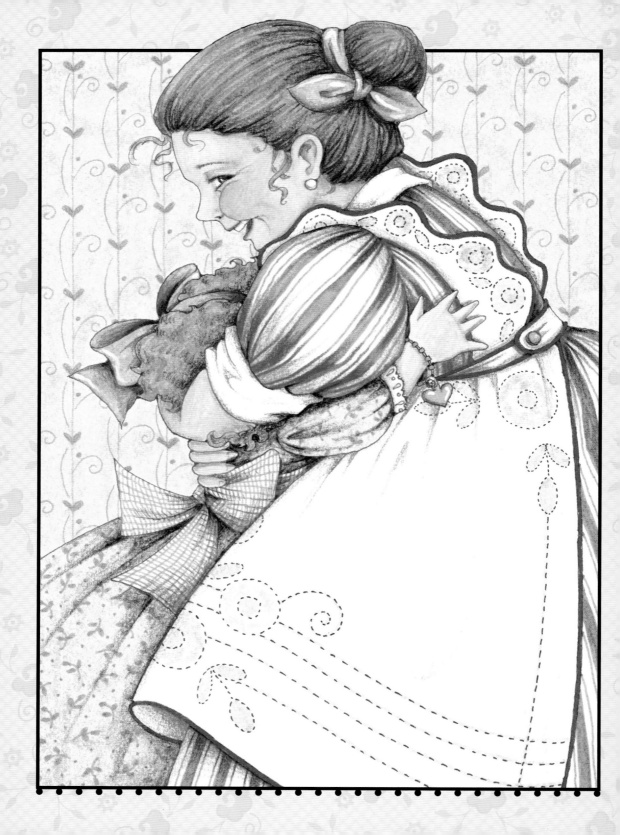

28
monday

3
thursday

St. David's Day (UK)

1
tuesday

4
friday

2
wednesday

5
saturday

6
sunday

February						
s	m	t	w	t	f	s
		1	2	3	4	5
6	7	8	9	10	11	12
13	14	15	16	17	18	19
20	21	22	23	24	25	26
27	28					

March						
s	m	t	w	t	f	s
		1	2	3	4	5
6	7	8	9	10	11	12
13	14	15	16	17	18	19
20	21	22	23	24	25	26
27	28	29	30	31		

*W*e loved with a love
that was more than love.

—Edgar Allan Poe

Labour Day (Australia—WA)

7
monday

10
thursday

International Women's Day

8
tuesday

11
friday

Ash Wednesday

9
wednesday

12
saturday

Daylight Saving Time
begins (USA)

13
sunday

March						
s	m	t	w	t	f	s
		1	2	3	4	5
6	7	8	9	10	11	12
13	14	15	16	17	18	19
20	21	22	23	24	25	26
27	28	29	30	31		

April						
s	m	t	w	t	f	s
					1	2
3	4	5	6	7	8	9
10	11	12	13	14	15	16
17	18	19	20	21	22	23
24	25	26	27	28	29	30

Mar 14 - 20

If you want happiness
for a lifetime,
help the next generation.

—Chinese proverb

Eight Hours Day (Australia—TAS)
Labour Day (Australia—VIC)
Canberra Day (Australia—ACT)
Commonwealth Day (Australia, Canada, NZ, UK)

14
monday

15
tuesday

16
wednesday

St. Patrick's Day

17
thursday

18
friday

19
saturday

Purim
First day of spring

20
sunday

		March				
s	m	t	w	t	f	s
		1	2	3	4	5
6	7	8	9	10	11	12
13	14	15	16	17	18	19
20	21	22	23	24	25	26
27	28	29	30	31		

		April				
s	m	t	w	t	f	s
					1	2
3	4	5	6	7	8	9
10	11	12	13	14	15	16
17	18	19	20	21	22	23
24	25	26	27	28	29	30

All Jewish holidays begin at sundown the previous day.

*C*hildren are the hands
by which we take hold
of heaven.

—Henry Ward Beecher

21
monday

24
thursday

22
tuesday

25
friday

23
wednesday

26
saturday

27
sunday

March

s	m	t	w	t	f	s
		1	2	3	4	5
6	7	8	9	10	11	12
13	14	15	16	17	18	19
20	21	22	23	24	25	26
27	28	29	30	31		

April

s	m	t	w	t	f	s
					1	2
3	4	5	6	7	8	9
10	11	12	13	14	15	16
17	18	19	20	21	22	23
24	25	26	27	28	29	30

What do we live for, if it is not to make life less difficult for each other?

—George Eliot

Mar 28 - Apr 3

28 monday

29 tuesday

30 wednesday

31 thursday

April Fools' Day

1 friday

2 saturday

Mothering Sunday
(Ireland, UK)

3 sunday

March

s	m	t	w	t	f	s
		1	2	3	4	5
6	7	8	9	10	11	12
13	14	15	16	17	18	19
20	21	22	23	24	25	26
27	28	29	30	31		

April

s	m	t	w	t	f	s
					1	2
3	4	5	6	7	8	9
10	11	12	13	14	15	16
17	18	19	20	21	22	23
24	25	26	27	28	29	30

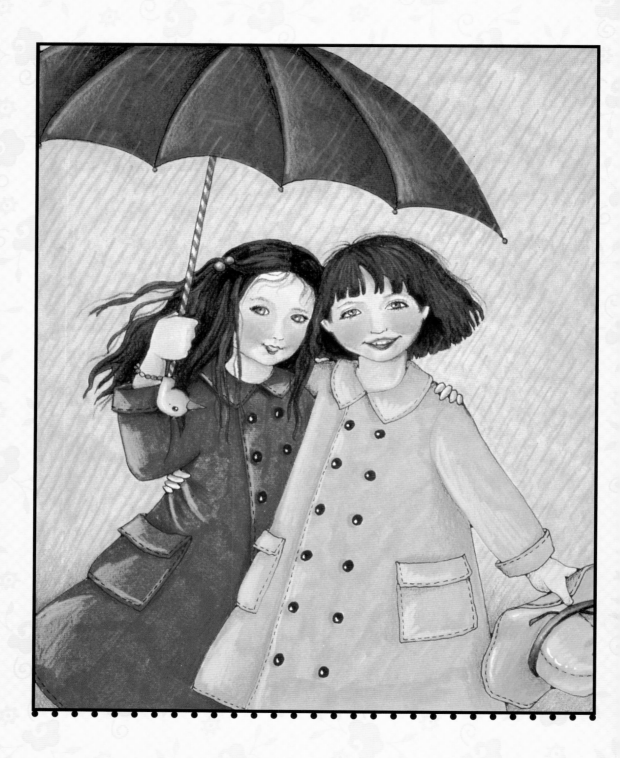

*F*riendship is a cozy shelter
from life's rainy days.

—Unknown

4
monday

7
thursday

5
tuesday

8
friday

6
wednesday

9
saturday

10
sunday

April						
s	m	t	w	t	f	s
					1	2
3	4	5	6	7	8	9
10	11	12	13	14	15	16
17	18	19	20	21	22	23
24	25	26	27	28	29	30

May						
s	m	t	w	t	f	s
1	2	3	4	5	6	7
8	9	10	11	12	13	14
15	16	17	18	19	20	21
22	23	24	25	26	27	28
29	30	31				

We have been friends together in sunshine and in shade.

—Caroline Sheridan Norton

Apr 11-17

11
monday

14
thursday

12
tuesday

15
friday

13
wednesday

16
saturday

Palm Sunday
17
sunday

April
s	m	t	w	t	f	s
					1	2
3	4	5	6	7	8	9
10	11	12	13	14	15	16
17	18	19	20	21	22	23
24	25	26	27	28	29	30

May
s	m	t	w	t	f	s
1	2	3	4	5	6	7
8	9	10	11	12	13	14
15	16	17	18	19	20	21
22	23	24	25	26	27	28
29	30	31				

Somebunny loves you

A hug delights and warms and charms, that must be why God gave us arms.

—Unknown

Apr 18 - 24

18 monday

21 thursday

Passover

19 tuesday

Good Friday (Western)
Holy Friday (Orthodox)
Earth Day

22 friday

20 wednesday

Easter Saturday
(Australia—except
TAS, WA)
St. George's
Day (UK)

23 saturday

Easter (Western,
Orthodox)

24 sunday

	April					
s	m	t	w	t	f	s
					1	2
3	4	5	6	7	8	9
10	11	12	13	14	15	16
17	18	19	20	21	22	23
24	25	26	27	28	29	30

	May					
s	m	t	w	t	f	s
1	2	3	4	5	6	7
8	9	10	11	12	13	14
15	16	17	18	19	20	21
22	23	24	25	26	27	28
29	30	31				

All Jewish holidays begin at sundown the previous day.

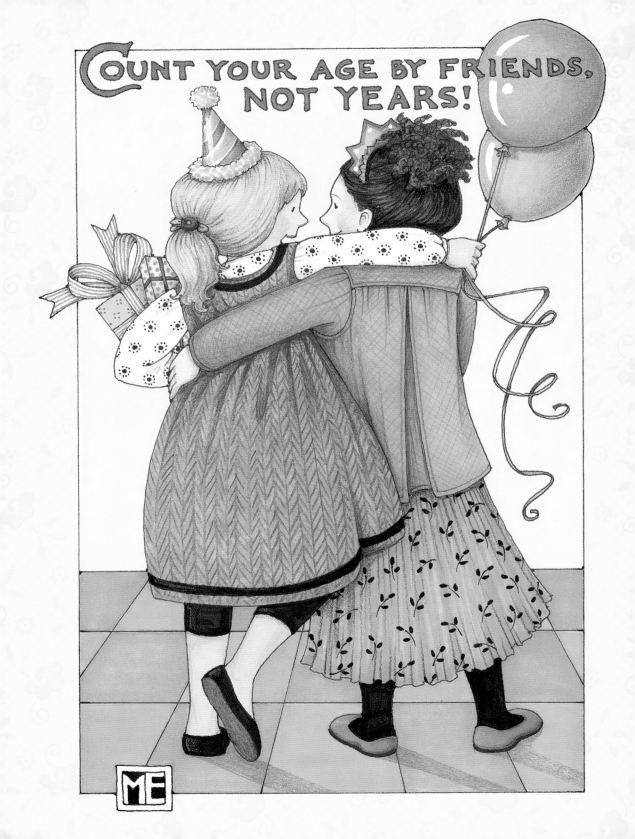

*I*t takes a long time to grow an old friend.

—John Leonard

Apr 25 - May 1

Easter Monday (Australia, Canada, Ireland, NZ, UK—except Scotland)
Anzac Day (NZ, Australia—except SA, VIC)

25 monday

Passover ends
Anzac Day (observed) (Australia—SA, VIC, WA)

26 tuesday

Administrative Professionals Day (USA)

27 wednesday

28 thursday

Arbor Day (USA)

29 friday

30 saturday

May Day

1 sunday

April

s	m	t	w	t	f	s
					1	2
3	4	5	6	7	8	9
10	11	12	13	14	15	16
17	18	19	20	21	22	23
24	25	26	27	28	29	30

May

s	m	t	w	t	f	s
1	2	3	4	5	6	7
8	9	10	11	12	13	14
15	16	17	18	19	20	21
22	23	24	25	26	27	28
29	30	31				

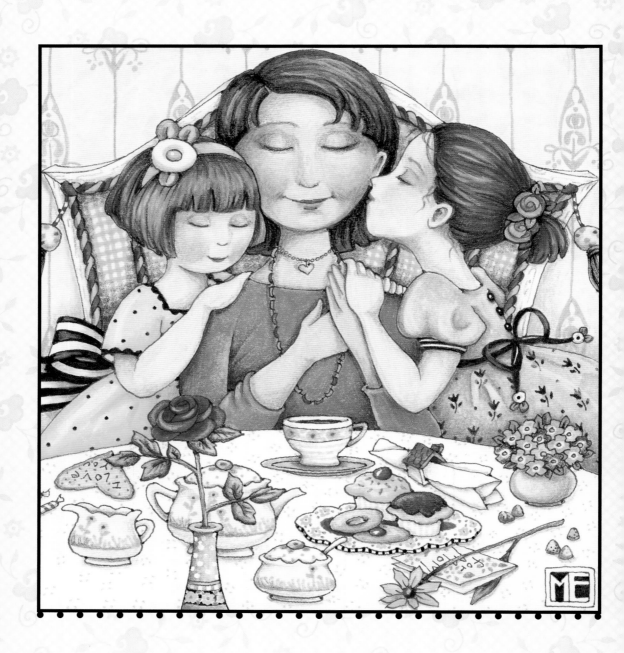

You can't wrap love in a box, but you can wrap a person in a hug.

—Unknown

May 2-8

Labour Day (Australia—QLD)
May Day (observed) (Australia—NT)
Early May Bank Holiday (Ireland, UK)

2 monday

National Teacher Day (USA)

3 tuesday

4 wednesday

5 thursday

Nurses Day (USA)

6 friday

7 saturday

Mother's Day (USA, Australia, Canada, NZ)

8 sunday

May						
s	m	t	w	t	f	s
1	2	3	4	5	6	7
8	9	10	11	12	13	14
15	16	17	18	19	20	21
22	23	24	25	26	27	28
29	30	31				

June						
s	m	t	w	t	f	s
			1	2	3	4
5	6	7	8	9	10	11
12	13	14	15	16	17	18
19	20	21	22	23	24	25
26	27	28	29	30		

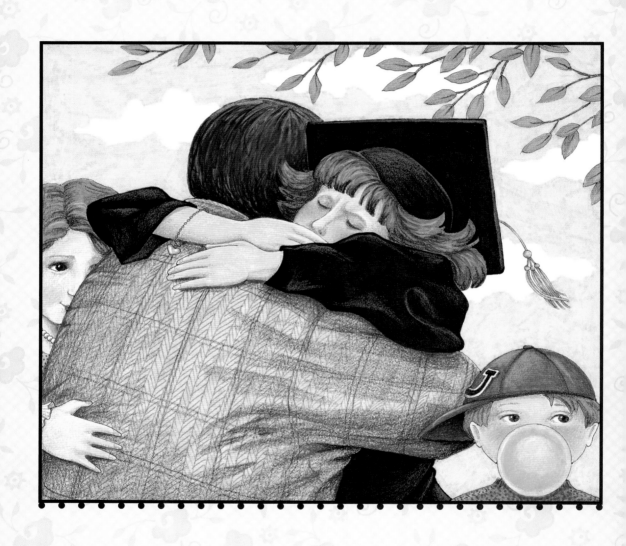

*L*ife isn't a matter of milestones but of moments.

—Rose F. Kennedy

May 9 - 15

9
monday

12
thursday

10
tuesday

13
friday

11
wednesday

14
saturday

15
sunday

May						
s	m	t	w	t	f	s
1	2	3	4	5	6	7
8	9	10	11	12	13	14
15	16	17	18	19	20	21
22	23	24	25	26	27	28
29	30	31				

June						
s	m	t	w	t	f	s
			1	2	3	4
5	6	7	8	9	10	11
12	13	14	15	16	17	18
19	20	21	22	23	24	25
26	27	28	29	30		

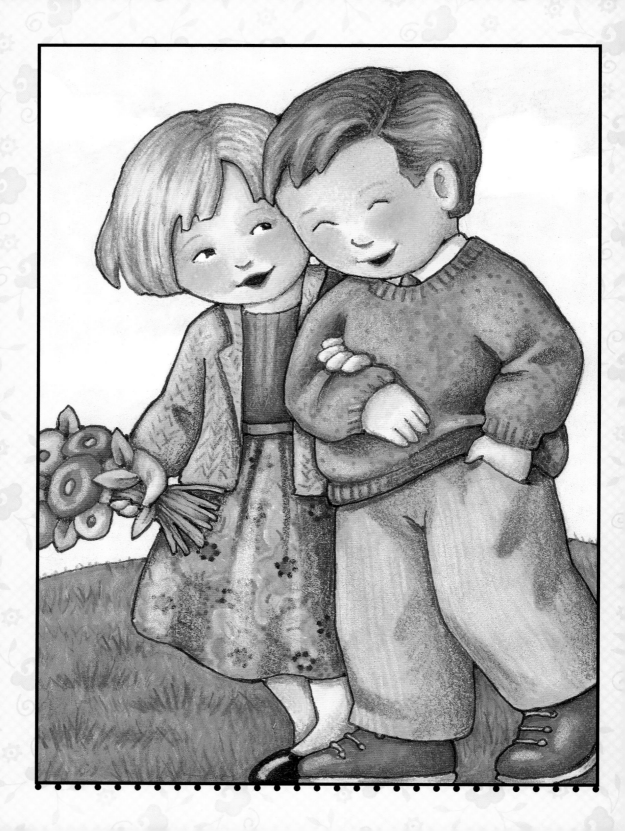

*T*he best thing to hold onto
in life is each other.
—Audrey Hepburn

May 16 - 22

16
monday

19
thursday

17
tuesday

20
friday

18
wednesday

Armed Forces Day
(USA)
21
saturday

22
sunday

	May					
s	m	t	w	t	f	s
1	2	3	4	5	6	7
8	9	10	11	12	13	14
15	16	17	18	19	20	21
22	23	24	25	26	27	28
29	30	31				

	June					
s	m	t	w	t	f	s
			1	2	3	4
5	6	7	8	9	10	11
12	13	14	15	16	17	18
19	20	21	22	23	24	25
26	27	28	29	30		

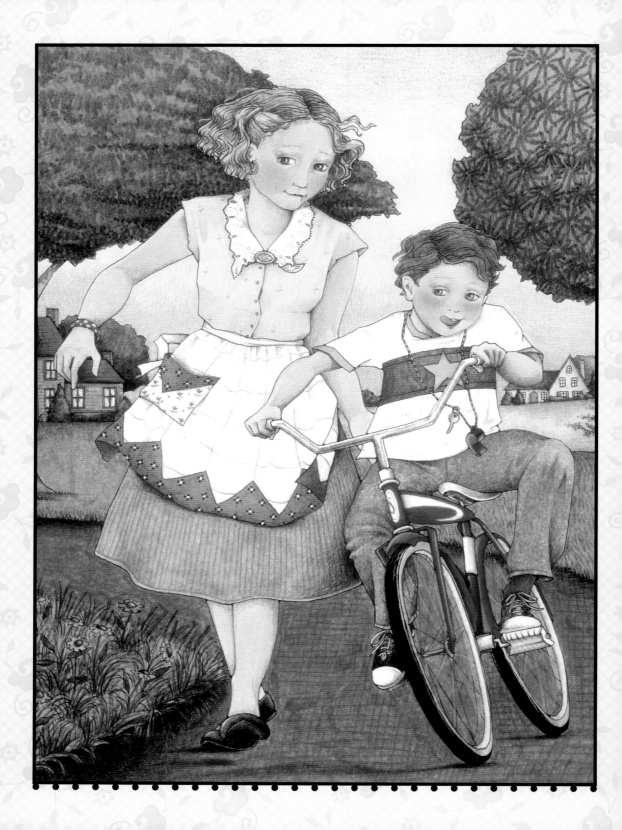

*M*other love is the fuel that enables a normal human being to do the impossible.

—Marion C. Garretty

May 23 - 29

Victoria Day (Canada)

23
monday

26
thursday

24
tuesday

27
friday

25
wednesday

28
saturday

29
sunday

			May			
s	m	t	w	t	f	s
1	2	3	4	5	6	7
8	9	10	11	12	13	14
15	16	17	18	19	20	21
22	23	24	25	26	27	28
29	30	31				

			June			
s	m	t	w	t	f	s
			1	2	3	4
5	6	7	8	9	10	11
12	13	14	15	16	17	18
19	20	21	22	23	24	25
26	27	28	29	30		

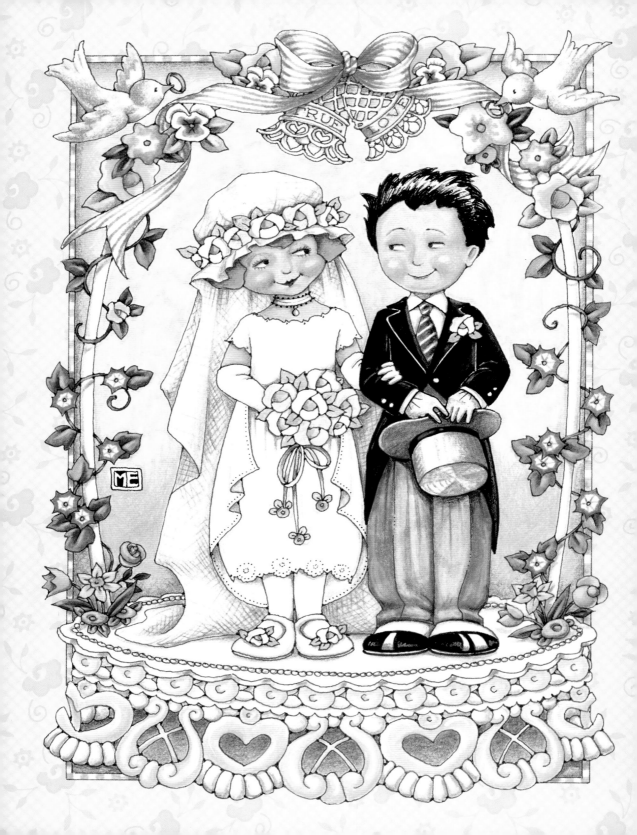

${\mathcal{N}}$ow join your hands, and with your hands your hearts.

—William Shakespeare

May 30 - Jun 5

Memorial Day (USA)
Spring Bank Holiday (UK)

30 monday

31 tuesday

1 wednesday

2 thursday

3 friday

4 saturday

5 sunday

May						
s	m	t	w	t	f	s
1	2	3	4	5	6	7
8	9	10	11	12	13	14
15	16	17	18	19	20	21
22	23	24	25	26	27	28
29	30	31				

June						
s	m	t	w	t	f	s
			1	2	3	4
5	6	7	8	9	10	11
12	13	14	15	16	17	18
19	20	21	22	23	24	25
26	27	28	29	30		

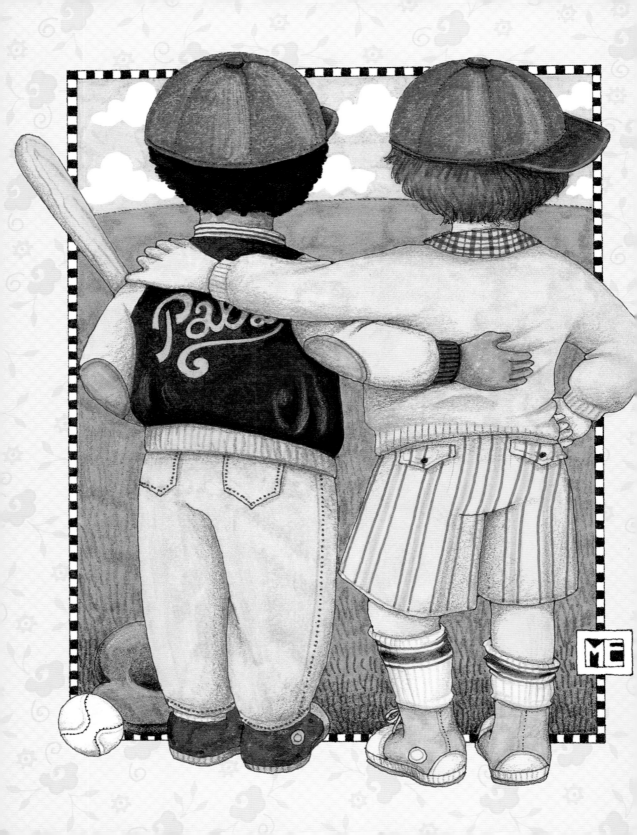

In my friend, I find a second self.

—Isabel Norton

Jun 6-12

Queen's Birthday (NZ)
Foundation Day (Australia—WA)
Bank Holiday (Ireland)

6
monday

9
thursday

7
tuesday

10
friday

8
wednesday

11
saturday

12
sunday

June						
s	m	t	w	t	f	s
			1	2	3	4
5	6	7	8	9	10	11
12	13	14	15	16	17	18
19	20	21	22	23	24	25
26	27	28	29	30		

July						
s	m	t	w	t	f	s
					1	2
3	4	5	6	7	8	9
10	11	12	13	14	15	16
17	18	19	20	21	22	23
24	25	26	27	28	29	30
31						

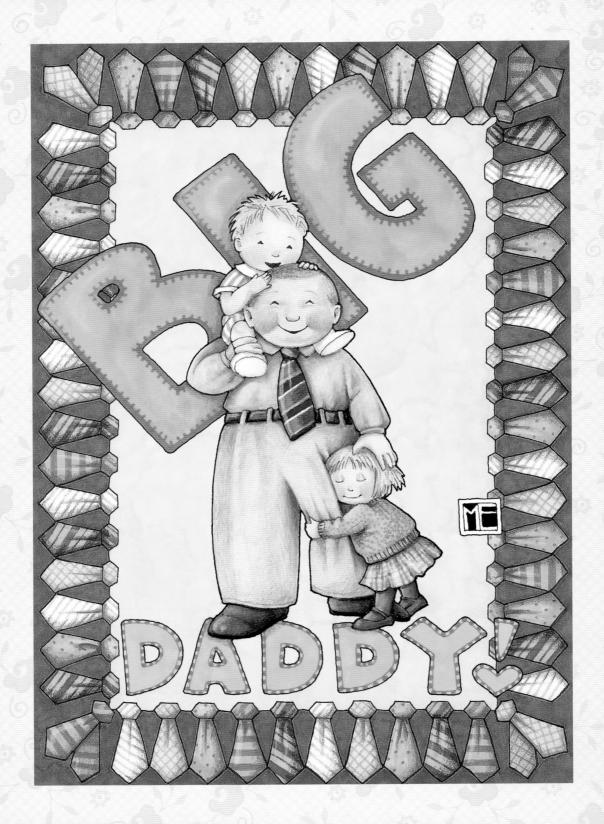

*S*afe, for a child,
 is his father's hand,
 holding him tight.

—Marion C. Garretty

Jun 13-19

Queen's Birthday (Australia—except WA)

13
monday

16
thursday

Flag Day (USA)

14
tuesday

17
friday

15
wednesday

18
saturday

Father's Day (USA,
Canada, Ireland, UK)

19
sunday

June						
s	m	t	w	t	f	s
			1	2	3	4
5	6	7	8	9	10	11
12	13	14	15	16	17	18
19	20	21	22	23	24	25
26	27	28	29	30		

July						
s	m	t	w	t	f	s
					1	2
3	4	5	6	7	8	9
10	11	12	13	14	15	16
17	18	19	20	21	22	23
24	25	26	27	28	29	30
31						

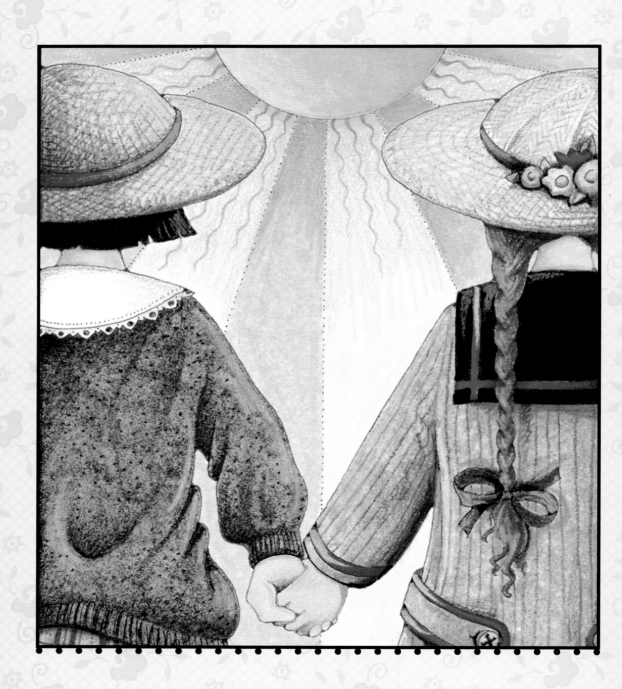

Remember, we all stumble, every one of us. That's why it's a comfort to go hand in hand.

—Emily Kimbrough

Jun 20 - 26

20
monday

First day of summer

21
tuesday

22
wednesday

23
thursday

24
friday

25
saturday

26
sunday

		June				
s	m	t	w	t	f	s
			1	2	3	4
5	6	7	8	9	10	11
12	13	14	15	16	17	18
19	20	21	22	23	24	25
26	27	28	29	30		

		July				
s	m	t	w	t	f	s
					1	2
3	4	5	6	7	8	9
10	11	12	13	14	15	16
17	18	19	20	21	22	23
24	25	26	27	28	29	30
31						

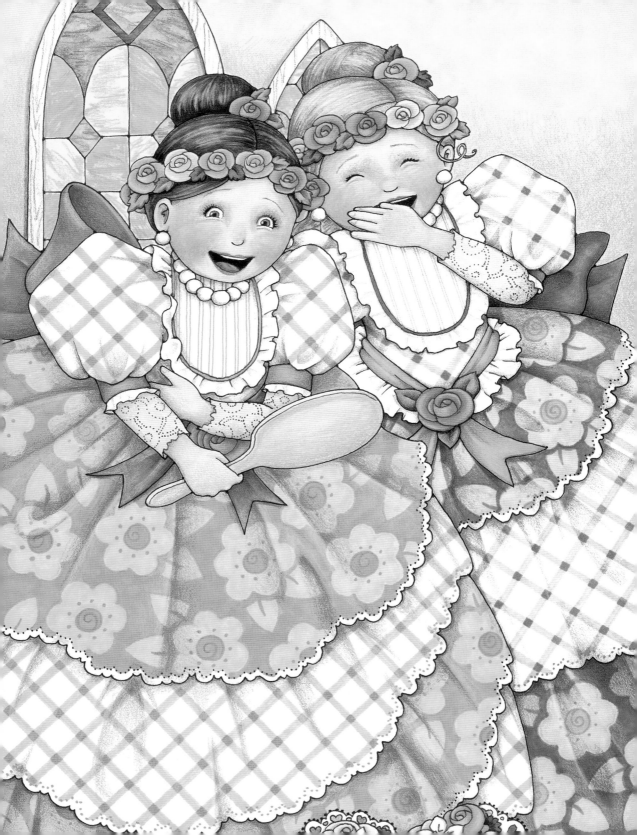

*The person who knows how
to laugh at himself
will never cease to be amused.*

—Shirley MacLaine

27
monday

30
thursday

28
tuesday

Canada Day

1
friday

29
wednesday

2
saturday

3
sunday

		June				
s	m	t	w	t	f	s
		1	2	3	4	
5	6	7	8	9	10	11
12	13	14	15	16	17	18
19	20	21	22	23	24	25
26	27	28	29	30		

		July				
s	m	t	w	t	f	s
					1	2
3	4	5	6	7	8	9
10	11	12	13	14	15	16
17	18	19	20	21	22	23
24	25	26	27	28	29	30
31						

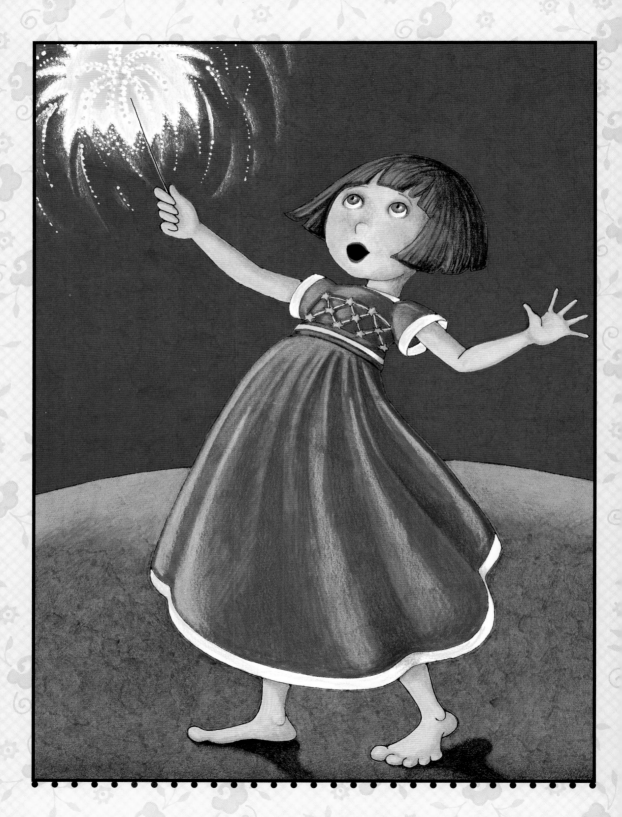

Freedom is nothing else but a chance to be better.

—Albert Camus

Jul 4 - 10

Independence Day (USA)

4
monday

7
thursday

5
tuesday

8
friday

6
wednesday

9
saturday

10
sunday

July						
s	m	t	w	t	f	s
					1	2
3	4	5	6	7	8	9
10	11	12	13	14	15	16
17	18	19	20	21	22	23
24	25	26	27	28	29	30
31						

August						
s	m	t	w	t	f	s
	1	2	3	4	5	6
7	8	9	10	11	12	13
14	15	16	17	18	19	20
21	22	23	24	25	26	27
28	29	30	31			

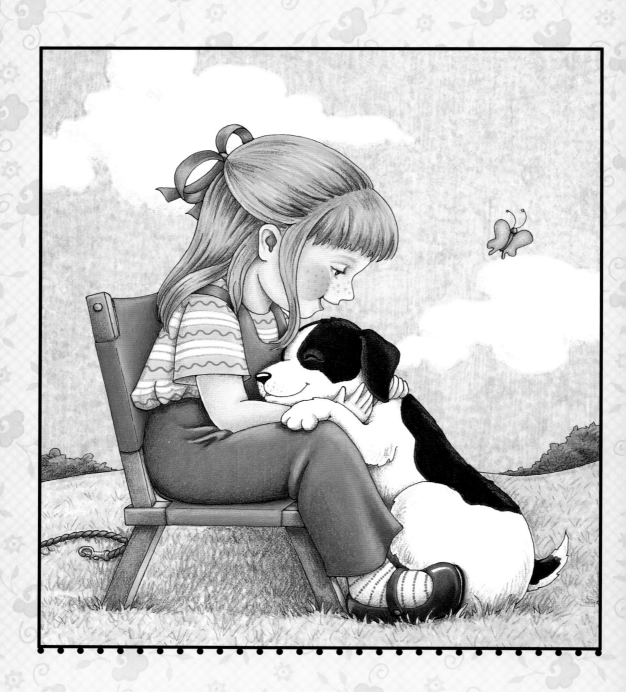

*W*hoever said you can't buy happiness forgot little puppies.

—Gene Hill

Jul 11-17

11
monday

14
thursday

12
tuesday

15
friday

13
wednesday

16
saturday

17
sunday

July
s	m	t	w	t	f	s
					1	2
3	4	5	6	7	8	9
10	11	12	13	14	15	16
17	18	19	20	21	22	23
24	25	26	27	28	29	30
31						

August
s	m	t	w	t	f	s
	1	2	3	4	5	6
7	8	9	10	11	12	13
14	15	16	17	18	19	20
21	22	23	24	25	26	27
28	29	30	31			

LOVE ONE ANOTHER

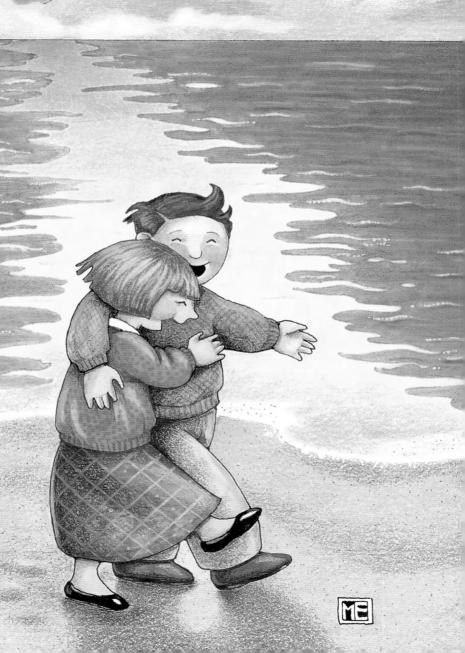

*B*eing deeply loved by someone gives you strength, while loving someone deeply gives you courage.

—Lao Tzu

Jul 18 - 24

18
monday

21
thursday

19
tuesday

22
friday

20
wednesday

23
saturday

24
sunday

July						
s	m	t	w	t	f	s
					1	2
3	4	5	6	7	8	9
10	11	12	13	14	15	16
17	18	19	20	21	22	23
24	25	26	27	28	29	30
31						

August						
s	m	t	w	t	f	s
	1	2	3	4	5	6
7	8	9	10	11	12	13
14	15	16	17	18	19	20
21	22	23	24	25	26	27
28	29	30	31			

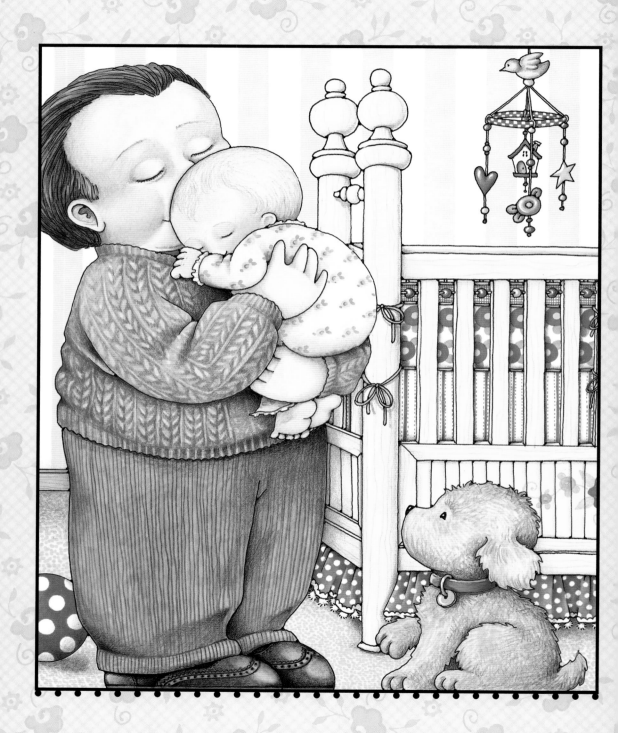

*E*very child comes
with the message that God
is not yet discouraged of man.

—Rabindranath Tagore

Jul 25 - 31

25
monday

28
thursday

26
tuesday

29
friday

27
wednesday

30
saturday

31
sunday

July
s	m	t	w	t	f	s
					1	2
3	4	5	6	7	8	9
10	11	12	13	14	15	16
17	18	19	20	21	22	23
24	25	26	27	28	29	30
31						

August
s	m	t	w	t	f	s
1	2	3	4	5	6	
7	8	9	10	11	12	13
14	15	16	17	18	19	20
21	22	23	24	25	26	27
28	29	30	31			

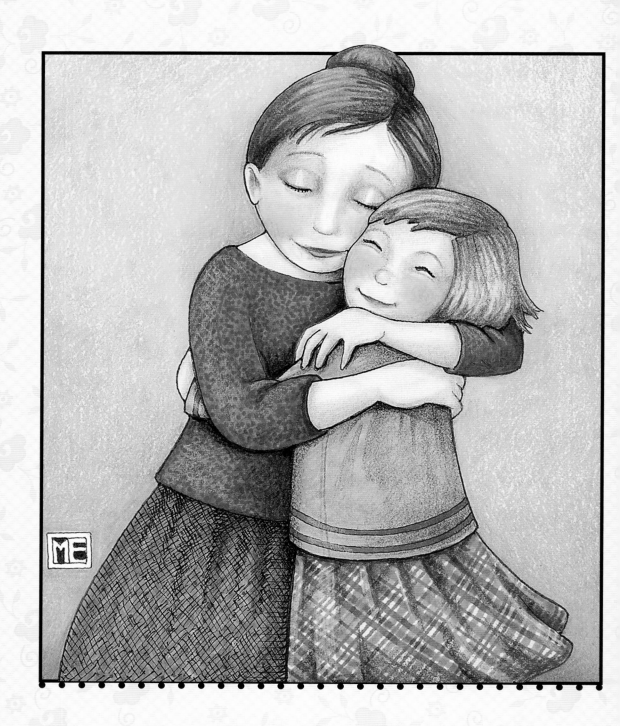

*M*other's love grows by giving.
—Charles Lamb

Aug 1-7

Ramadan
Bank Holiday (Ireland, UK—Scotland, Australia—NSW)
Picnic Day (Australia—NT)

1 monday

4 thursday

2 tuesday

5 friday

3 wednesday

6 saturday

7 sunday

August						
s	m	t	w	t	f	s
	1	2	3	4	5	6
7	8	9	10	11	12	13
14	15	16	17	18	19	20
21	22	23	24	25	26	27
28	29	30	31			

September						
s	m	t	w	t	f	s
				1	2	3
4	5	6	7	8	9	10
11	12	13	14	15	16	17
18	19	20	21	22	23	24
25	26	27	28	29	30	

All Islamic holidays begin at sundown the previous day.

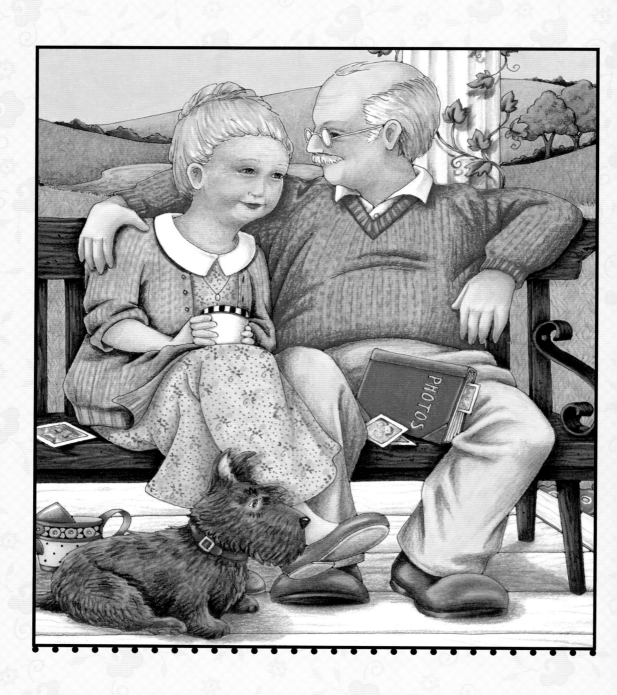

We do not remember days;
we remember moments.
—Cesare Pavese

Aug 8-14

8
monday

11
thursday

9
tuesday

12
friday

10
wednesday

13
saturday

14
sunday

August							
s	m	t	w	t	f	s	
		1	2	3	4	5	6
7	8	9	10	11	12	13	
14	15	16	17	18	19	20	
21	22	23	24	25	26	27	
28	29	30	31				

September						
s	m	t	w	t	f	s
				1	2	3
4	5	6	7	8	9	10
11	12	13	14	15	16	17
18	19	20	21	22	23	24
25	26	27	28	29	30	

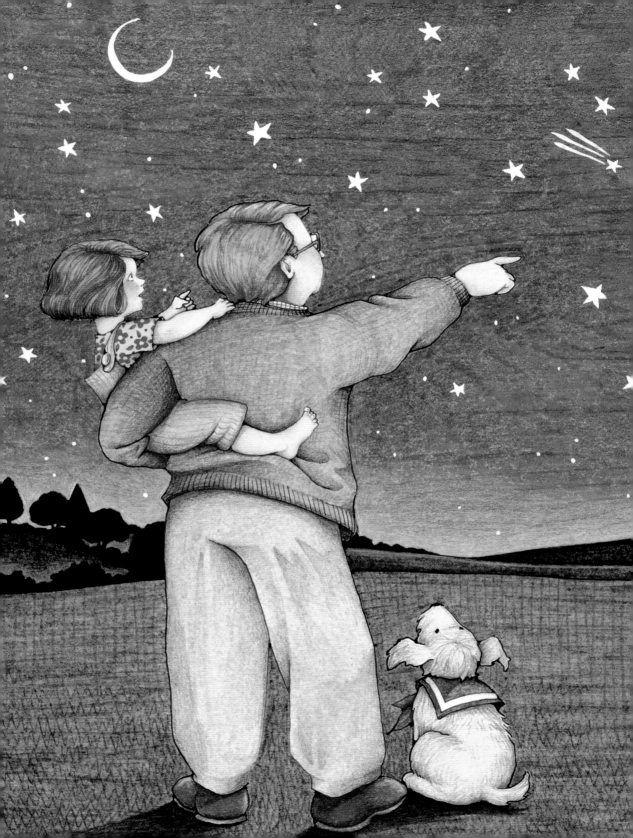

*R*eal elation is when you feel you could touch a star without standing on tiptoe.

—Doug Larson

Aug 15 - 21

15
monday

18
thursday

16
tuesday

19
friday

17
wednesday

20
saturday

21
sunday

August
s	m	t	w	t	f	s
	1	2	3	4	5	6
7	8	9	10	11	12	13
14	15	16	17	18	19	20
21	22	23	24	25	26	27
28	29	30	31			

September
s	m	t	w	t	f	s
				1	2	3
4	5	6	7	8	9	10
11	12	13	14	15	16	17
18	19	20	21	22	23	24
25	26	27	28	29	30	

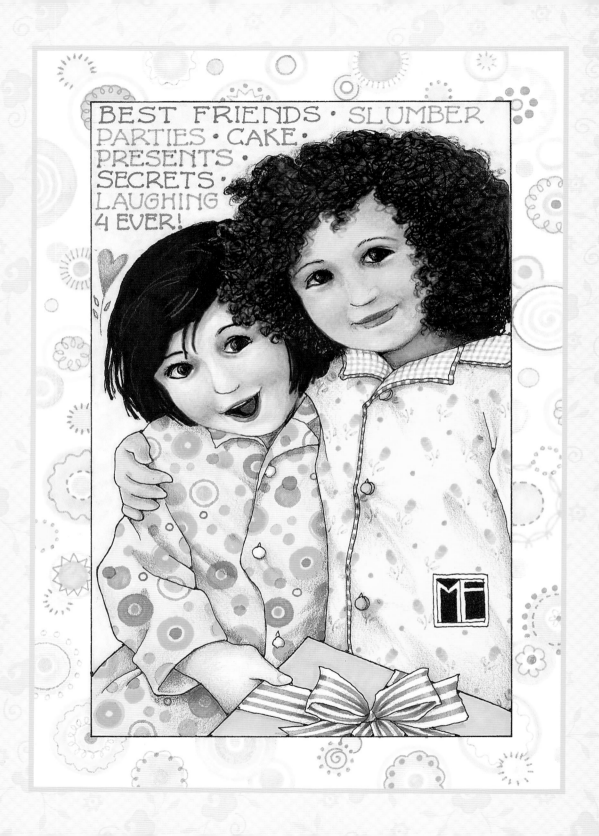

A friend is one of the nicest things you can have, and one of the best things you can be.

—Douglas Pagels

Aug 22 - 28

22 monday

25 thursday

23 tuesday

26 friday

24 wednesday

27 saturday

28 sunday

August

s	m	t	w	t	f	s
	1	2	3	4	5	6
7	8	9	10	11	12	13
14	15	16	17	18	19	20
21	22	23	24	25	26	27
28	29	30	31			

September

s	m	t	w	t	f	s
				1	2	3
4	5	6	7	8	9	10
11	12	13	14	15	16	17
18	19	20	21	22	23	24
25	26	27	28	29	30	

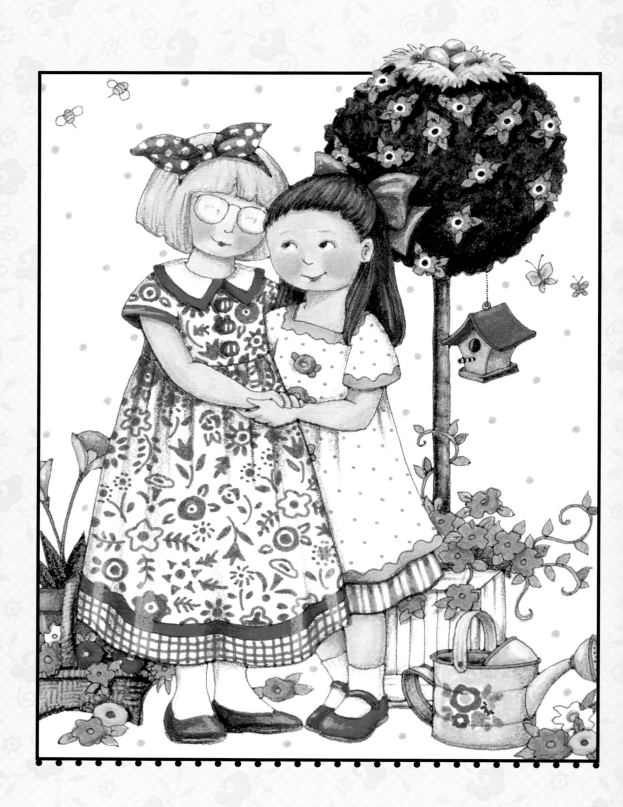

*L*et us be grateful to people who make us happy, they are the charming gardeners who make our souls blossom.
—Marcel Proust

Aug 29 - Sep 4

Summer Bank Holiday (UK—except Scotland)

29
monday

Eid al-Fitr

30
tuesday

31
wednesday

1
thursday

2
friday

3
saturday

Father's Day (Australia, NZ)

4
sunday

August

s	m	t	w	t	f	s
	1	2	3	4	5	6
7	8	9	10	11	12	13
14	15	16	17	18	19	20
21	22	23	24	25	26	27
28	29	30	31			

September

s	m	t	w	t	f	s
				1	2	3
4	5	6	7	8	9	10
11	12	13	14	15	16	17
18	19	20	21	22	23	24
25	26	27	28	29	30	

All Islamic holidays begin at sundown the previous day.

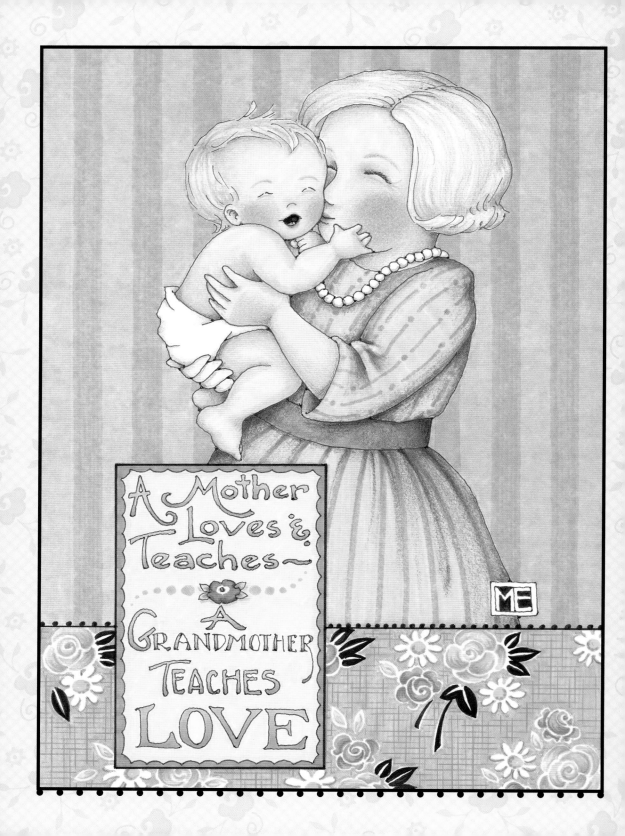

It is as grandmothers
that our mothers come into
the fullness of their grace.

—Christopher Morley

Sep 5 -11

Labor Day (USA, Canada)

5
monday

8
thursday

6
tuesday

9
friday

7
wednesday

10
saturday

National Grandparents
Day (USA)

11
sunday

September
s	m	t	w	t	f	s
				1	2	3
4	5	6	7	8	9	10
11	12	13	14	15	16	17
18	19	20	21	22	23	24
25	26	27	28	29	30	

October
s	m	t	w	t	f	s
						1
2	3	4	5	6	7	8
9	10	11	12	13	14	15
16	17	18	19	20	21	22
23	24	25	26	27	28	29
30	31					

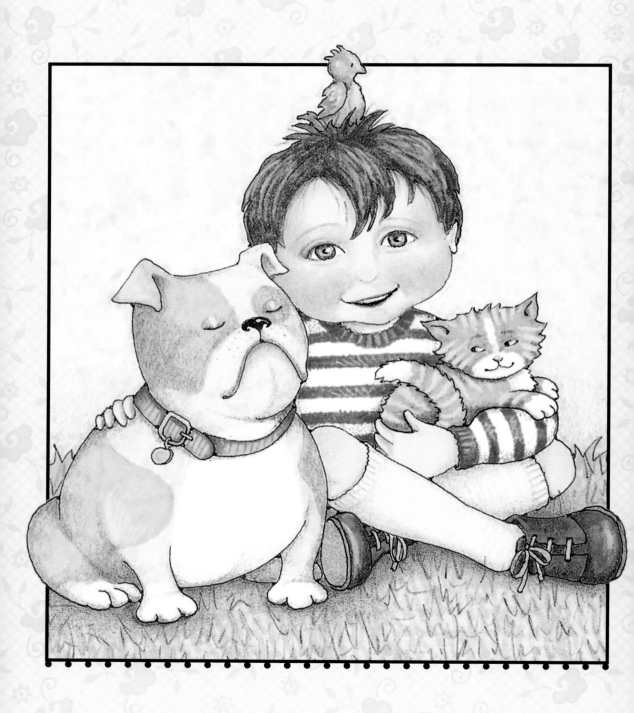

The cat could very well be man's best friend but would never stoop to admitting it.
—Doug Larson

Sep 12-18

12
monday

15
thursday

13
tuesday

16
friday

14
wednesday

17
saturday

18
sunday

September						
s	m	t	w	t	f	s
				1	2	3
4	5	6	7	8	9	10
11	12	13	14	15	16	17
18	19	20	21	22	23	24
25	26	27	28	29	30	

October						
s	m	t	w	t	f	s
						1
2	3	4	5	6	7	8
9	10	11	12	13	14	15
16	17	18	19	20	21	22
23	24	25	26	27	28	29
30	31					

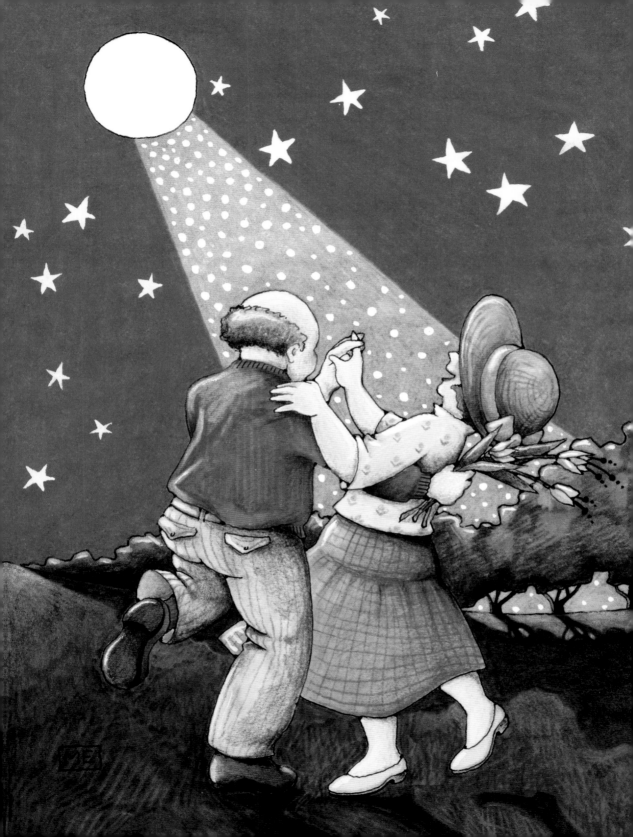

When two close kindred meet
what better than call a dance?
—William Butler Yeats

Sep 19 - 25

19
monday

22
thursday

20
tuesday

First day of autumn

23
friday

U.N. International Day of Peace

21
wednesday

24
saturday

25
sunday

September						
s	m	t	w	t	f	s
				1	2	3
4	5	6	7	8	9	10
11	12	13	14	15	16	17
18	19	20	21	22	23	24
25	26	27	28	29	30	

October						
s	m	t	w	t	f	s
						1
2	3	4	5	6	7	8
9	10	11	12	13	14	15
16	17	18	19	20	21	22
23	24	25	26	27	28	29
30	31					

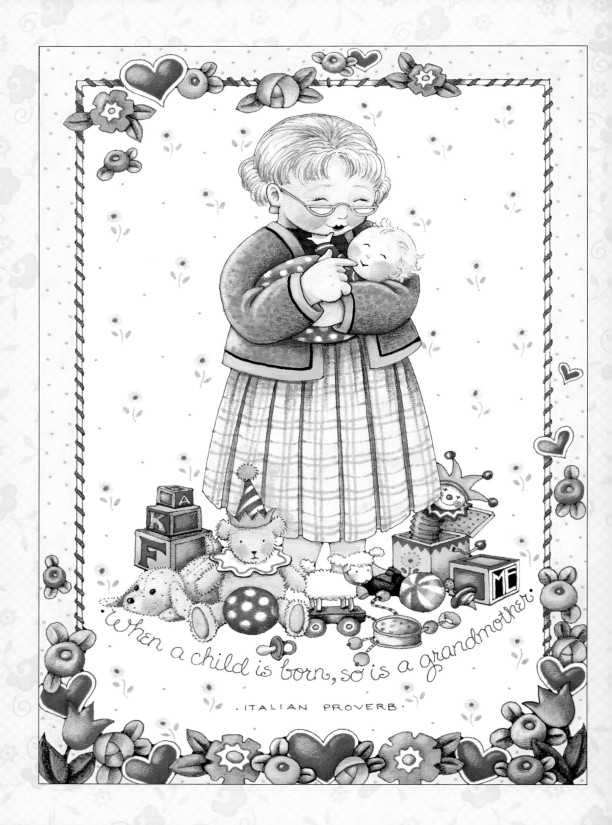

When a child is born, so is a grandmother

·ITALIAN PROVERB·

*G*randchildren are the dots
that connect the lines
from generation to generation.

—Lois Wyse

Sep 26 - Oct 2

26
monday

Rosh Hashanah

29
thursday

27
tuesday

Rosh Hashanah ends

30
friday

28
wednesday

1
saturday

2
sunday

September						
s	m	t	w	t	f	s
				1	2	3
4	5	6	7	8	9	10
11	12	13	14	15	16	17
18	19	20	21	22	23	24
25	26	27	28	29	30	

October						
s	m	t	w	t	f	s
						1
2	3	4	5	6	7	8
9	10	11	12	13	14	15
16	17	18	19	20	21	22
23	24	25	26	27	28	29
30	31					

All Jewish holidays begin at sundown the previous day.

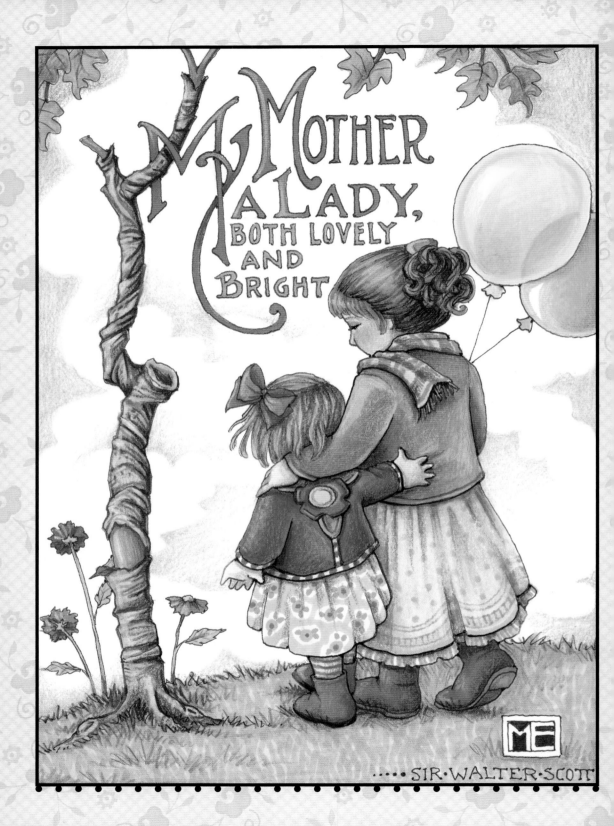

MY MOTHER A LADY, BOTH LOVELY AND BRIGHT

..... SIR · WALTER · SCOTT

The best conversations with mothers always take place in silence, when only the heart speaks.

—Carrie Latet

Oct 3 - 9

Labour Day (Australia—ACT, NSW, SA)
Queen's Birthday (Australia—WA)

3
monday

6
thursday

4
tuesday

7
friday

5
wednesday

Yom Kippur

8
saturday

9
sunday

October						
s	m	t	w	t	f	s
						1
2	3	4	5	6	7	8
9	10	11	12	13	14	15
16	17	18	19	20	21	22
23	24	25	26	27	28	29
30	31					

November						
s	m	t	w	t	f	s
		1	2	3	4	5
6	7	8	9	10	11	12
13	14	15	16	17	18	19
20	21	22	23	24	25	26
27	28	29	30			

All Jewish holidays begin at sundown the previous day.

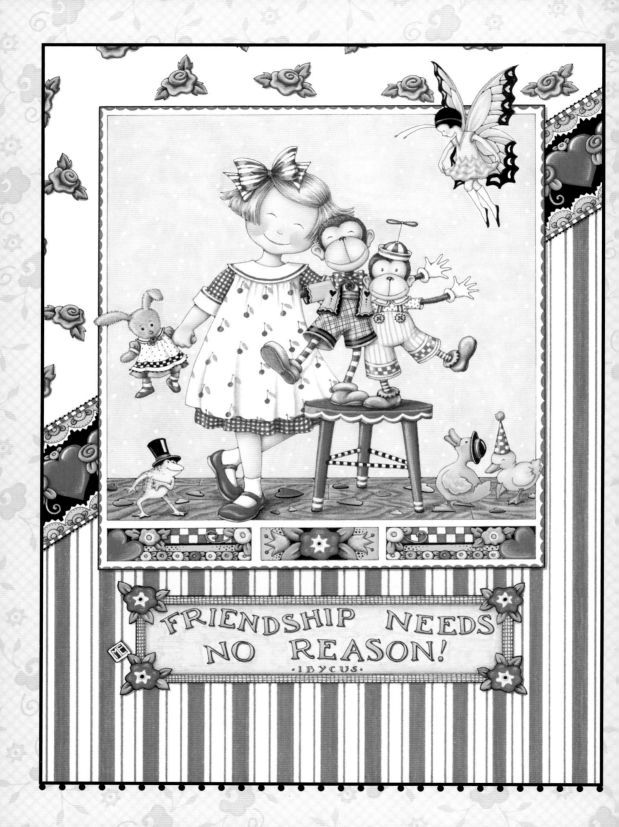

FRIENDSHIP NEEDS NO REASON!

·IBYCUS·

*T*he world always looks brighter from behind a smile.

—Unknown

Oct 10 - 16

Columbus Day (USA)
Thanksgiving (Canada)

10
monday

11
tuesday

12
wednesday

13
thursday

14
friday

National Boss Day (USA)

15
saturday

16
sunday

October

s	m	t	w	t	f	s
						1
2	3	4	5	6	7	8
9	10	11	12	13	14	15
16	17	18	19	20	21	22
23	24	25	26	27	28	29
30	31					

November

s	m	t	w	t	f	s
		1	2	3	4	5
6	7	8	9	10	11	12
13	14	15	16	17	18	19
20	21	22	23	24	25	26
27	28	29	30			

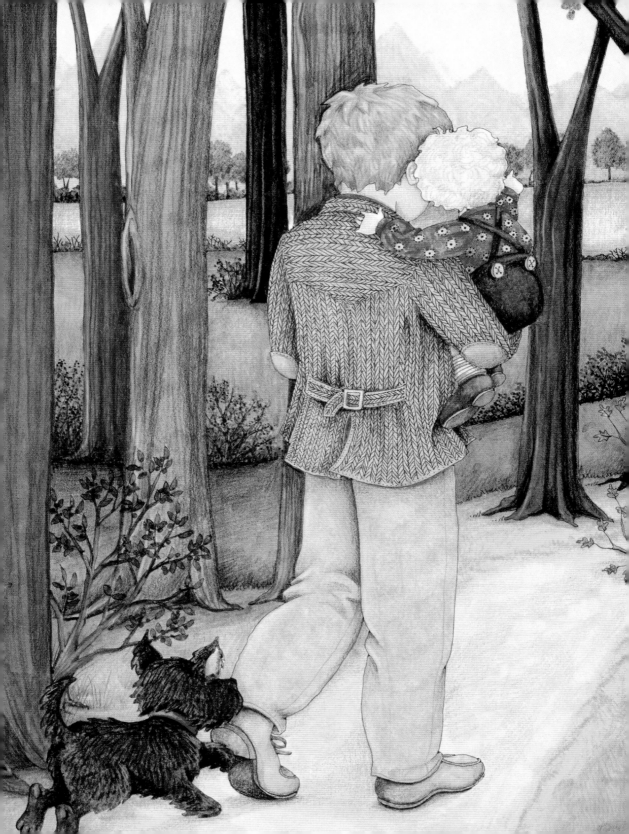

Oct 17 - 23

*B*lessed indeed is the man
who hears many gentle voices
call him father!

—Lydia Maria Child

17
monday

20
thursday

18
tuesday

21
friday

19
wednesday

22
saturday

23
sunday

October
s	m	t	w	t	f	s
						1
2	3	4	5	6	7	8
9	10	11	12	13	14	15
16	17	18	19	20	21	22
23	24	25	26	27	28	29
30	31					

November
s	m	t	w	t	f	s
		1	2	3	4	5
6	7	8	9	10	11	12
13	14	15	16	17	18	19
20	21	22	23	24	25	26
27	28	29	30			

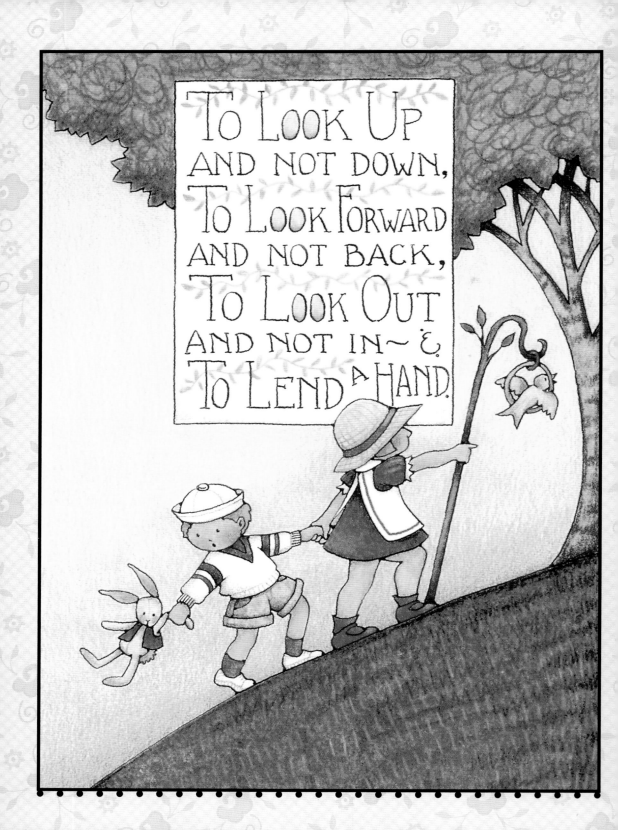

United Nations Day
Labour Day (NZ)

24
monday

27
thursday

25
tuesday

28
friday

26
wednesday

29
saturday

30
sunday

October						
s	m	t	w	t	f	s
						1
2	3	4	5	6	7	8
9	10	11	12	13	14	15
16	17	18	19	20	21	22
23	24	25	26	27	28	29
30	31					

November						
s	m	t	w	t	f	s
		1	2	3	4	5
6	7	8	9	10	11	12
13	14	15	16	17	18	19
20	21	22	23	24	25	26
27	28	29	30			

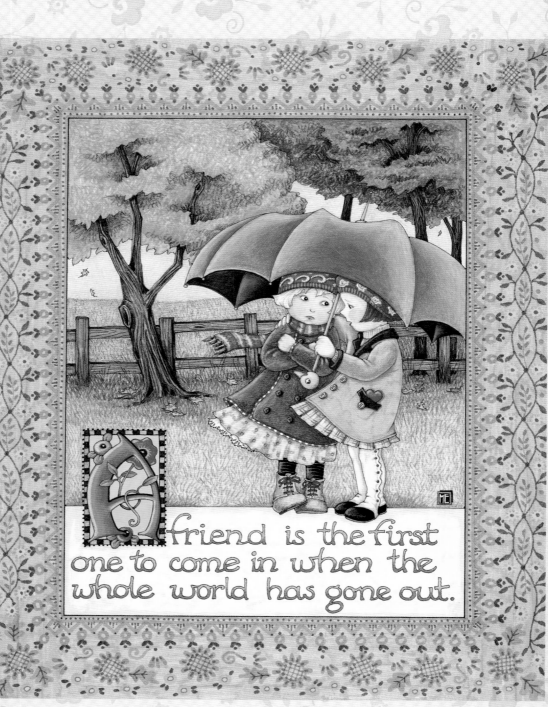

friend is the first one to come in when the whole world has gone out.

*G*od gave burdens, also shoulders.

—*Yiddish proverb*

Oct 31 - Nov 6

Halloween
Bank Holiday (Ireland)

31
monday

3
thursday

1
tuesday

4
friday

2
wednesday

5
saturday

Eid al-Adha
Daylight Saving Time
ends (USA)

6
sunday

October

s	m	t	w	t	f	s
						1
2	3	4	5	6	7	8
9	10	11	12	13	14	15
16	17	18	19	20	21	22
23	24	25	26	27	28	29
30	31					

November

s	m	t	w	t	f	s
		1	2	3	4	5
6	7	8	9	10	11	12
13	14	15	16	17	18	19
20	21	22	23	24	25	26
27	28	29	30			

All Islamic holidays begin at sundown the previous day.

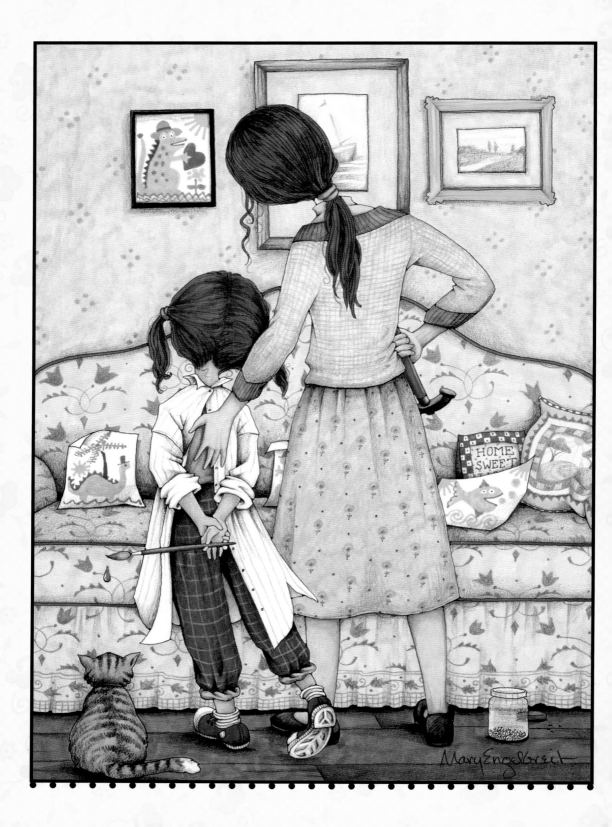

Women are aristocrats, and it is always the mother who makes us feel that we belong to the better sort.

—John Lancaster Spalding

Nov 7 - 13

7
monday

Election Day (USA)

8
tuesday

9
wednesday

10
thursday

Veterans' Day (USA)
Remembrance Day (Canada, Ireland, UK)

11
friday

12
saturday

13
sunday

November

s	m	t	w	t	f	s
		1	2	3	4	5
6	7	8	9	10	11	12
13	14	15	16	17	18	19
20	21	22	23	24	25	26
27	28	29	30			

December

s	m	t	w	t	f	s
				1	2	3
4	5	6	7	8	9	10
11	12	13	14	15	16	17
18	19	20	21	22	23	24
25	26	27	28	29	30	31

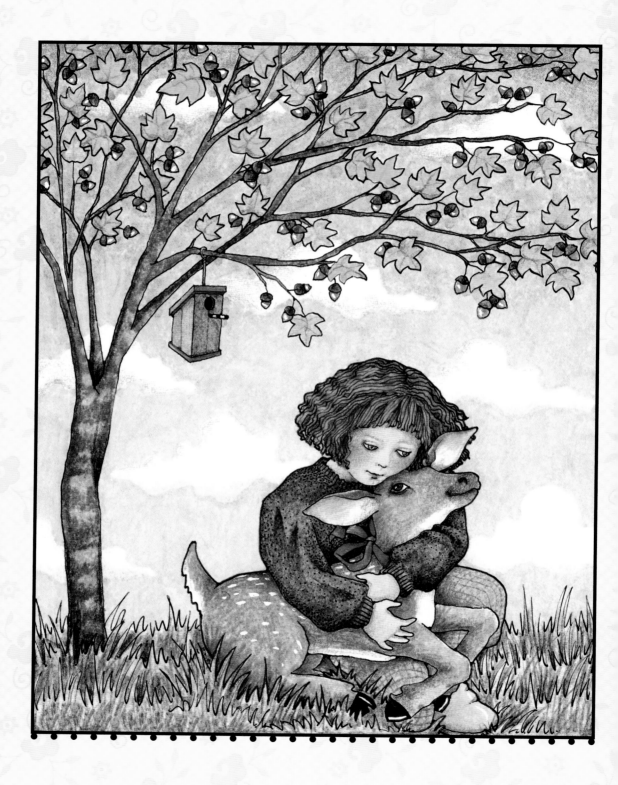

A friend may well be reckoned
the masterpiece of nature.
—Ralph Waldo Emerson

Nov 14 - 20

14
monday

17
thursday

15
tuesday

18
friday

16
wednesday

19
saturday

20
sunday

November						
s	m	t	w	t	f	s
		1	2	3	4	5
6	7	8	9	10	11	12
13	14	15	16	17	18	19
20	21	22	23	24	25	26
27	28	29	30			

December						
s	m	t	w	t	f	s
				1	2	3
4	5	6	7	8	9	10
11	12	13	14	15	16	17
18	19	20	21	22	23	24
25	26	27	28	29	30	31

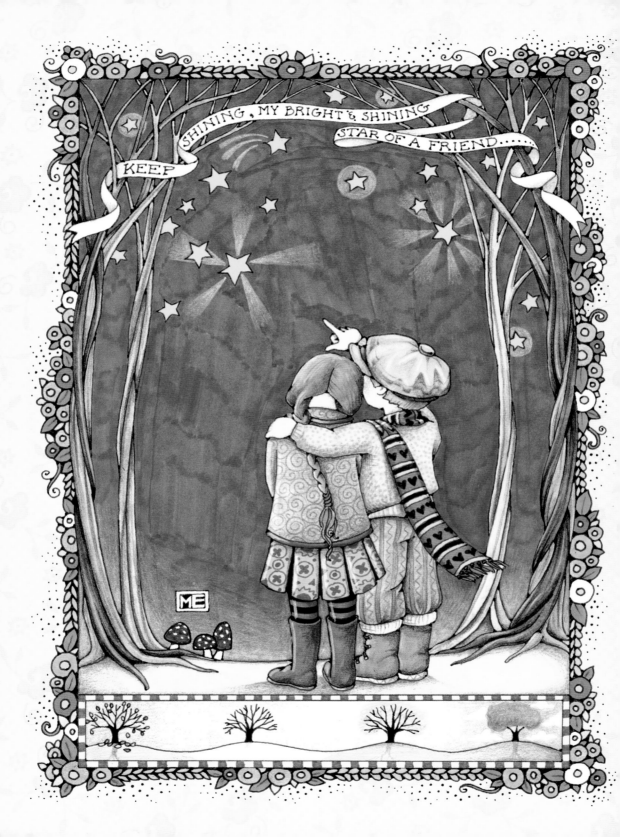

*H*ope is faith holding out
its hand in the dark.

—George Iles

Nov 21 - 27

21
monday

Thanksgiving (USA)

24
thursday

22
tuesday

25
friday

23
wednesday

26
saturday

27
sunday

November						
s	m	t	w	t	f	s
		1	2	3	4	5
6	7	8	9	10	11	12
13	14	15	16	17	18	19
20	21	22	23	24	25	26
27	28	29	30			

December						
s	m	t	w	t	f	s
				1	2	3
4	5	6	7	8	9	10
11	12	13	14	15	16	17
18	19	20	21	22	23	24
25	26	27	28	29	30	31

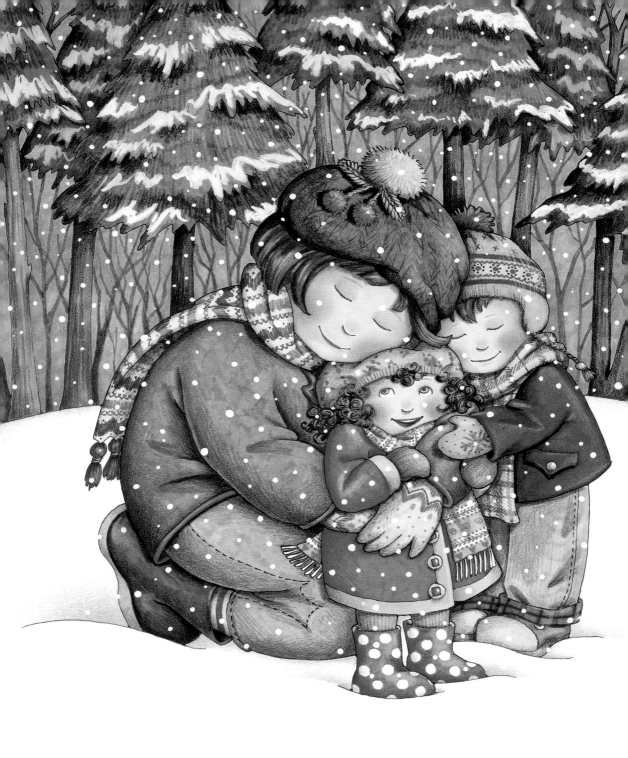

They invented hugs to let people know you love them without saying anything.

—Bil Keane

Nov 28 - Dec 4

28
monday

1
thursday

29
tuesday

2
friday

St. Andrew's Day (UK)

30
wednesday

3
saturday

4
sunday

November						
s	m	t	w	t	f	s
		1	2	3	4	5
6	7	8	9	10	11	12
13	14	15	16	17	18	19
20	21	22	23	24	25	26
27	28	29	30			

December						
s	m	t	w	t	f	s
				1	2	3
4	5	6	7	8	9	10
11	12	13	14	15	16	17
18	19	20	21	22	23	24
25	26	27	28	29	30	31

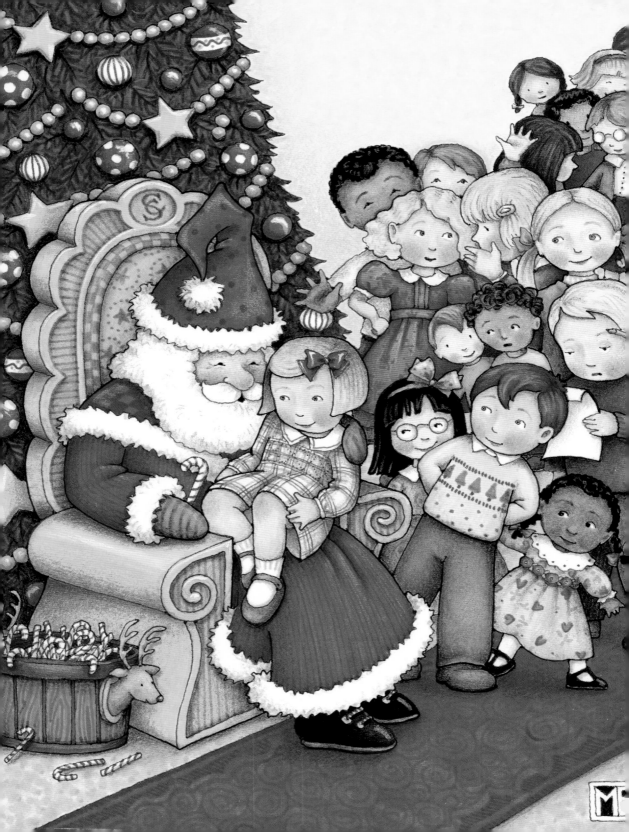

A hug is a great gift—
one size fits all,
and it's easy to exchange.
—Unknown

Dec 5 - 11

5
monday

8
thursday

6
tuesday

9
friday

7
wednesday

Human Rights Day
10
saturday

11
sunday

December						
s	m	t	w	t	f	s
				1	2	3
4	5	6	7	8	9	10
11	12	13	14	15	16	17
18	19	20	21	22	23	24
25	26	27	28	29	30	31

January '12						
s	m	t	w	t	f	s
1	2	3	4	5	6	7
8	9	10	11	12	13	14
15	16	17	18	19	20	21
22	23	24	25	26	27	28
29	30	31				

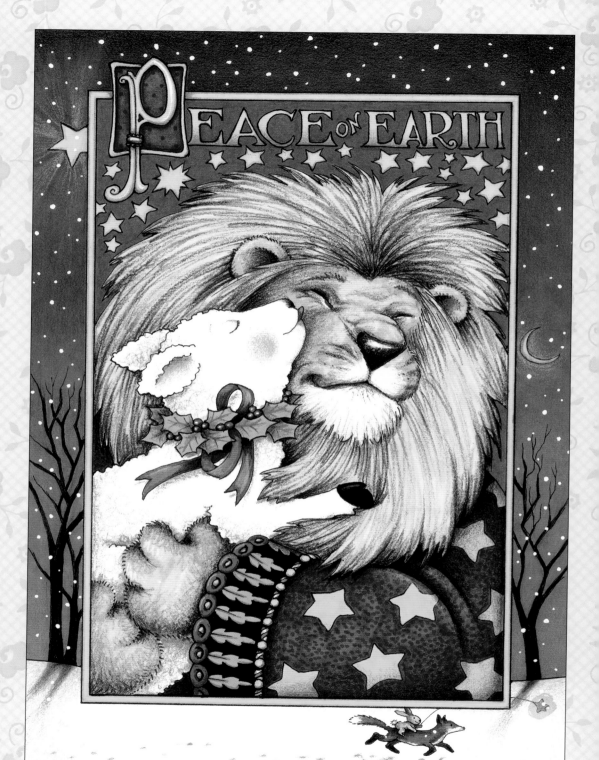

A kiss without a hug is like a flower without the fragrance.

—Proverb

Dec 12 - 18

12
monday

15
thursday

13
tuesday

16
friday

14
wednesday

17
saturday

18
sunday

December
s	m	t	w	t	f	s
				1	2	3
4	5	6	7	8	9	10
11	12	13	14	15	16	17
18	19	20	21	22	23	24
25	26	27	28	29	30	31

January '12
s	m	t	w	t	f	s
1	2	3	4	5	6	7
8	9	10	11	12	13	14
15	16	17	18	19	20	21
22	23	24	25	26	27	28
29	30	31				

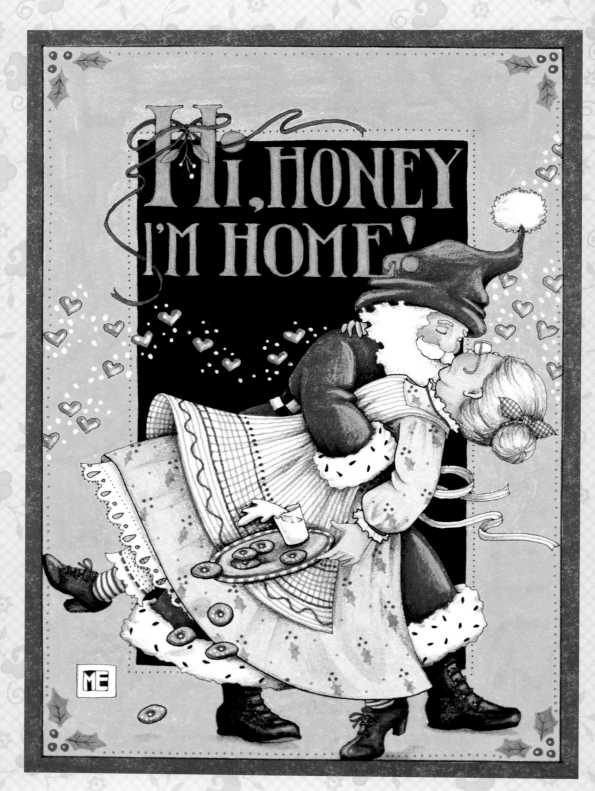

19 monday

First day of winter

22 thursday

20 tuesday

23 friday

Hanukkah

21 wednesday

Christmas Eve

24 saturday

Christmas Day

25 sunday

December
s	m	t	w	t	f	s
				1	2	3
4	5	6	7	8	9	10
11	12	13	14	15	16	17
18	19	20	21	22	23	24
25	26	27	28	29	30	31

January '12
s	m	t	w	t	f	s
1	2	3	4	5	6	7
8	9	10	11	12	13	14
15	16	17	18	19	20	21
22	23	24	25	26	27	28
29	30	31				

All Jewish holidays begin at sundown the previous day.

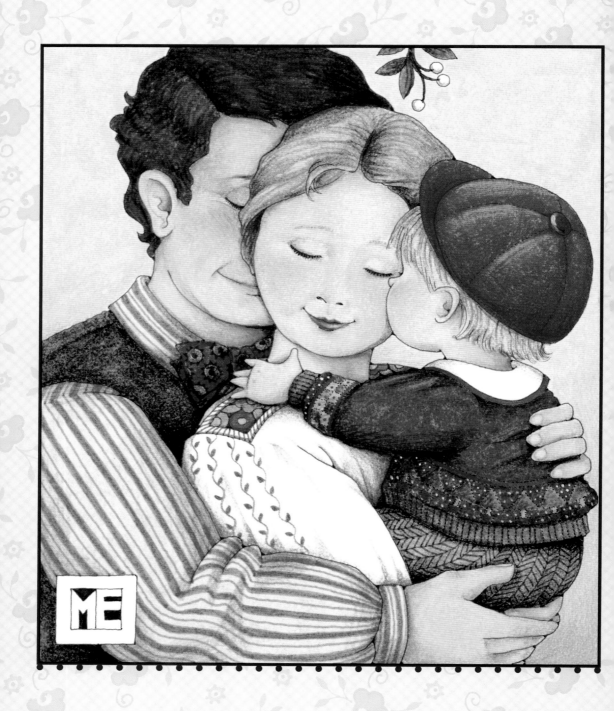

Home is where the hugs are!
—Unknown

Dec 26 - Jan 1

Kwanzaa begins (USA)
Christmas Day (observed) (UK, Australia—except TAS, VIC)
Boxing Day (Canada, NZ, Australia—TAS, VIC)
St. Stephen's Day (Ireland)

26 monday

29 thursday

Christmas Day (observed) (Ireland, NZ, Australia—TAS, VIC)
Boxing Day (observed) (UK, Australia—except SA, TAS, VIC)
Proclamation Day (Australia—SA)

27 tuesday

30 friday

Hanukkah ends

28 wednesday

31 saturday

New Year's Day
Kwanzaa ends (USA)

1 sunday

December

s	m	t	w	t	f	s
				1	2	3
4	5	6	7	8	9	10
11	12	13	14	15	16	17
18	19	20	21	22	23	24
25	26	27	28	29	30	31

January '12

s	m	t	w	t	f	s
1	2	3	4	5	6	7
8	9	10	11	12	13	14
15	16	17	18	19	20	21
22	23	24	25	26	27	28
29	30	31				

2011 Holidays

Date	Holiday
January 1	New Year's Day
January 1	Kwanzaa ends (USA)
January 3	New Year's Day (observed) (Ireland, NZ, UK, Australia—except NSW)
January 4	Bank Holiday (Scotland)
January 17	Martin Luther King Jr.'s Birthday (observed) (USA)
January 26	Australia Day
February 6	Waitangi Day (NZ)
February 14	St. Valentine's Day
February 21	Presidents' Day (USA)
March 1	St. David's Day (UK)
March 7	Labour Day (Australia—WA)
March 8	International Women's Day
March 9	Ash Wednesday
March 13	Daylight Saving Time begins (USA)
March 14	Eight Hours Day (Australia—TAS)
March 14	Labour Day (Australia—VIC)
March 14	Canberra Day (Australia—ACT)
March 14	Commonwealth Day (Australia, Canada, NZ, UK)
March 17	St. Patrick's Day
March 20	Purim
March 20	First day of spring
April 1	April Fools' Day
April 3	Mothering Sunday (Ireland, UK)
April 17	Palm Sunday
April 19	Passover
April 22	Good Friday (Western)
April 22	Holy Friday (Orthodox)
April 22	Earth Day
April 23	Easter Saturday (Australia—except TAS, WA)
April 23	St. George's Day (UK)
April 24	Easter (Western, Orthodox)
April 25	Easter Monday (Australia, Canada, Ireland, NZ, UK—except Scotland)
April 25	Anzac Day (NZ, Australia—except SA, VIC)
April 26	Passover ends
April 26	Anzac Day (observed) (Australia—SA, VIC, WA)
April 27	Administrative Professionals Day (USA)
April 29	Arbor Day (USA)

Date	Holiday
May 1	May Day
May 2	Labour Day (Australia—QLD)
May 2	May Day (observed) (Australia—NT)
May 2	Early May Bank Holiday (Ireland, UK)
May 3	National Teacher Day (USA)
May 6	Nurses Day (USA)
May 8	Mother's Day (USA, Australia, Canada, NZ)
May 21	Armed Forces Day (USA)
May 23	Victoria Day (Canada)
May 30	Memorial Day (USA)
May 30	Spring Bank Holiday (UK)
June 6	Queen's Birthday (NZ)
June 6	Foundation Day (Australia—WA)
June 6	Bank Holiday (Ireland)
June 13	Queen's Birthday (Australia—except WA)
June 14	Flag Day (USA)
June 19	Father's Day (USA, Canada, Ireland, UK)
June 21	First day of summer
July 1	Canada Day
July 4	Independence Day (USA)
August 1	Ramadan
August 1	Bank Holiday (Ireland, UK—Scotland, Australia—NSW)
August 1	Picnic Day (Australia—NT)
August 29	Summer Bank Holiday (UK—except Scotland)
August 30	Eid al-Fitr
September 4	Father's Day (Australia, NZ)
September 5	Labor Day (USA, Canada)
September 11	National Grandparents Day (USA)
September 21	U.N. International Day of Peace
September 23	First day of autumn
September 29	Rosh Hashanah
September 30	Rosh Hashanah ends

Date	Holiday
October 3	Labour Day (Australia—ACT, NSW, SA)
October 3	Queen's Birthday (Australia—WA)
October 8	Yom Kippur
October 10	Columbus Day (USA)
October 10	Thanksgiving (Canada)
October 16	National Boss Day (USA)
October 24	United Nations Day
October 24	Labour Day (NZ)
October 31	Halloween
October 31	Bank Holiday (Ireland)
November 6	Eid al-Adha
November 6	Daylight Saving Time ends (USA)
November 8	Election Day (USA)
November 11	Veterans' Day (USA)
November 11	Remembrance Day (Canada, Ireland, UK)
November 24	Thanksgiving (USA)
November 30	St. Andrew's Day (UK)
December 10	Human Rights Day
December 21	Hanukkah
December 22	First day of winter
December 24	Christmas Eve
December 25	Christmas Day
December 26	Kwanzaa begins (USA)
December 26	Christmas Day (observed) (UK, Australia—except TAS, VIC)
December 26	Boxing Day (Canada, NZ, Australia—TAS, VIC)
December 26	St. Stephen's Day (Ireland)
December 27	Christmas Day (observed) (Ireland, NZ, Australia—TAS, VIC)
December 27	Boxing Day (observed) (UK, Australia—except SA, TAS, VIC)
December 27	Proclamation Day (Australia—SA)
December 28	Hanukkah ends

All Jewish and Islamic holidays begin at sundown the previous day.

2012 Looking Ahead...

January

February

March

April

May

June

July

August

September

October

November

December

Birthdays & Anniversaries

January

February

May

June

September

October

March

April

July

August

November

December

Babysitters

Name _____
Home Phone _____
Cell _____
Notes _____

Name _____
Home Phone _____
Cell _____
Notes _____

Name _____
Home Phone _____
Cell _____
Notes _____

Name _____
Home Phone _____
Cell _____
Notes _____

Name _____
Home Phone _____
Cell _____
Notes _____

Name _____
Home Phone _____
Cell _____
Notes _____

Name _____
Home Phone _____
Cell _____
Notes _____

Name _____
Home Phone _____
Cell _____
Notes _____

Name _____
Home Phone _____
Cell _____
Notes _____

Name _____
Home Phone _____
Cell _____
Notes _____

Name _____
Home Phone _____
Cell _____
Notes _____

Name _____
Home Phone _____
Cell _____
Notes _____

Children's Friends

Name_____
Parents_____
Address_____

Home Phone_____
Cell_____

Name_____
Parents_____
Address_____

Home Phone_____
Cell_____

Name_____
Parents_____
Address_____

Home Phone_____
Cell_____

Name_____
Parents_____
Address_____

Home Phone_____
Cell_____

Name_____
Parents_____
Address_____

Home Phone_____
Cell_____

Name_____
Parents_____
Address_____

Home Phone_____
Cell_____

Name_____
Parents_____
Address_____

Home Phone_____
Cell_____

Name_____
Parents_____
Address_____

Home Phone_____
Cell_____

Names & Numbers

Name _____
Address _____

Home Phone _____
Cell _____
E-Mail _____

Name _____
Address _____

Home Phone _____
Cell _____
E-Mail _____

Name _____
Address _____

Home Phone _____
Cell _____
E-Mail _____

Name _____
Address _____

Home Phone _____
Cell _____
E-Mail _____

Name _____
Address _____

Home Phone _____
Cell _____
E-Mail _____

Name _____
Address _____

Home Phone _____
Cell _____
E-Mail _____

Name _____
Address _____

Home Phone _____
Cell _____
E-Mail _____

Name _____
Address _____

Home Phone _____
Cell _____
E-Mail _____

Names & Numbers

Name _____
Address _____

Home Phone _____
Cell _____
E-Mail _____

Name _____
Address _____

Home Phone _____
Cell _____
E-Mail _____

Name _____
Address _____

Home Phone _____
Cell _____
E-Mail _____

Name _____
Address _____

Home Phone _____
Cell _____
E-Mail _____

Name _____
Address _____

Home Phone _____
Cell _____
E-Mail _____

Name _____
Address _____

Home Phone _____
Cell _____
E-Mail _____

Name _____
Address _____

Home Phone _____
Cell _____
E-Mail _____

Name _____
Address _____

Home Phone _____
Cell _____
E-Mail _____

Names & Numbers

Name _____
Address _____

Home Phone _____
Cell _____
E-Mail _____

Name _____
Address _____

Home Phone _____
Cell _____
E-Mail _____

Name _____
Address _____

Home Phone _____
Cell _____
E-Mail _____

Name _____
Address _____

Home Phone _____
Cell _____
E-Mail _____

Name _____
Address _____

Home Phone _____
Cell _____
E-Mail _____

Name _____
Address _____

Home Phone _____
Cell _____
E-Mail _____

Name _____
Address _____

Home Phone _____
Cell _____
E-Mail _____

Name _____
Address _____

Home Phone _____
Cell _____
E-Mail _____

Names & Numbers

Name _____
Address _____

Home Phone _____
Cell _____
E-Mail _____

Name _____
Address _____

Home Phone _____
Cell _____
E-Mail _____

Name _____
Address _____

Home Phone _____
Cell _____
E-Mail _____

Name _____
Address _____

Home Phone _____
Cell _____
E-Mail _____

Name _____
Address _____

Home Phone _____
Cell _____
E-Mail _____

Name _____
Address _____

Home Phone _____
Cell _____
E-Mail _____

Name _____
Address _____

Home Phone _____
Cell _____
E-Mail _____

Name _____
Address _____

Home Phone _____
Cell _____
E-Mail _____

Web Sites

Notes

Notes

2010

January
s	m	t	w	t	f	s
					1	2
3	4	5	6	7	8	9
10	11	12	13	14	15	16
17	18	19	20	21	22	23
24	25	26	27	28	29	30
31						

February
s	m	t	w	t	f	s
	1	2	3	4	5	6
7	8	9	10	11	12	13
14	15	16	17	18	19	20
21	22	23	24	25	26	27
28						

March
s	m	t	w	t	f	s
	1	2	3	4	5	6
7	8	9	10	11	12	13
14	15	16	17	18	19	20
21	22	23	24	25	26	27
28	29	30	31			

April
s	m	t	w	t	f	s
				1	2	3
4	5	6	7	8	9	10
11	12	13	14	15	16	17
18	19	20	21	22	23	24
25	26	27	28	29	30	

May
s	m	t	w	t	f	s
						1
2	3	4	5	6	7	8
9	10	11	12	13	14	15
16	17	18	19	20	21	22
23	24	25	26	27	28	29
30	31					

June
s	m	t	w	t	f	s
		1	2	3	4	5
6	7	8	9	10	11	12
13	14	15	16	17	18	19
20	21	22	23	24	25	26
27	28	29	30			

July
s	m	t	w	t	f	s
				1	2	3
4	5	6	7	8	9	10
11	12	13	14	15	16	17
18	19	20	21	22	23	24
25	26	27	28	29	30	31

August
s	m	t	w	t	f	s
1	2	3	4	5	6	7
8	9	10	11	12	13	14
15	16	17	18	19	20	21
22	23	24	25	26	27	28
29	30	31				

September
s	m	t	w	t	f	s
			1	2	3	4
5	6	7	8	9	10	11
12	13	14	15	16	17	18
19	20	21	22	23	24	25
26	27	28	29	30		

October
s	m	t	w	t	f	s
					1	2
3	4	5	6	7	8	9
10	11	12	13	14	15	16
17	18	19	20	21	22	23
24	25	26	27	28	29	30
31						

November
s	m	t	w	t	f	s
	1	2	3	4	5	6
7	8	9	10	11	12	13
14	15	16	17	18	19	20
21	22	23	24	25	26	27
28	29	30				

December
s	m	t	w	t	f	s
			1	2	3	4
5	6	7	8	9	10	11
12	13	14	15	16	17	18
19	20	21	22	23	24	25
26	27	28	29	30	31	

2012

January
s	m	t	w	t	f	s
1	2	3	4	5	6	7
8	9	10	11	12	13	14
15	16	17	18	19	20	21
22	23	24	25	26	27	28
29	30	31				

February
s	m	t	w	t	f	s
			1	2	3	4
5	6	7	8	9	10	11
12	13	14	15	16	17	18
19	20	21	22	23	24	25
26	27	28	29			

March
s	m	t	w	t	f	s
				1	2	3
4	5	6	7	8	9	10
11	12	13	14	15	16	17
18	19	20	21	22	23	24
25	26	27	28	29	30	31

April
s	m	t	w	t	f	s
1	2	3	4	5	6	7
8	9	10	11	12	13	14
15	16	17	18	19	20	21
22	23	24	25	26	27	28
29	30					

May
s	m	t	w	t	f	s
		1	2	3	4	5
6	7	8	9	10	11	12
13	14	15	16	17	18	19
20	21	22	23	24	25	26
27	28	29	30	31		

June
s	m	t	w	t	f	s
					1	2
3	4	5	6	7	8	9
10	11	12	13	14	15	16
17	18	19	20	21	22	23
24	25	26	27	28	29	30

July
s	m	t	w	t	f	s
1	2	3	4	5	6	7
8	9	10	11	12	13	14
15	16	17	18	19	20	21
22	23	24	25	26	27	28
29	30	31				

August
s	m	t	w	t	f	s
			1	2	3	4
5	6	7	8	9	10	11
12	13	14	15	16	17	18
19	20	21	22	23	24	25
26	27	28	29	30	31	

September
s	m	t	w	t	f	s
						1
2	3	4	5	6	7	8
9	10	11	12	13	14	15
16	17	18	19	20	21	22
23	24	25	26	27	28	29
30						

October
s	m	t	w	t	f	s
	1	2	3	4	5	6
7	8	9	10	11	12	13
14	15	16	17	18	19	20
21	22	23	24	25	26	27
28	29	30	31			

November
s	m	t	w	t	f	s
				1	2	3
4	5	6	7	8	9	10
11	12	13	14	15	16	17
18	19	20	21	22	23	24
25	26	27	28	29	30	

December
s	m	t	w	t	f	s
						1
2	3	4	5	6	7	8
9	10	11	12	13	14	15
16	17	18	19	20	21	22
23	24	25	26	27	28	29
30	31					